IMAGES
of America

BROADVIEW HEIGHTS

July 2016

Nick & Pat,

Thank you for Supporting
the Broadview Heights
Historical Society!!

Don "Butch"

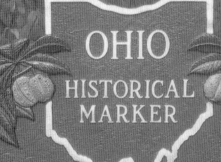

OHIO
HISTORICAL MARKER

BRECKSVILLE TOWNSHIP'S FIRST SETTLER

In 1811, Colonel John Breck sent Seth Paine to survey a new township of the Western Reserve. Traveling from Massachusetts, the Paine family journeyed by wagon pulled by a team of oxen, a trip that took them forty-two days. For his compensation, Paine was given 200 acres of land that is now part of the cities of Broadview Heights, Brecksville, and North Royalton. He chose acreage in the southwestern area of the township and built the first family structure in this area. His log cabin sat on the northeast corner of Broadview and Boston roads and later became one of the first schoolhouses from which his daughter, Orianna, taught. The vast body of land that Colonel Breck was granted the authority to allot was given the name Brecksville Township. In 1818, the west end of Brecksville Township, consisting of 21.28 square miles, was renamed Royalton Township.

BROADVIEW HEIGHTS HISTORICAL SOCIETY
THE OHIO HISTORICAL SOCIETY

2009 92-18

This Ohio State historical marker was placed on the northeast corner of Broadview and Boston Roads by the Broadview Heights Historical Society and the Ohio Historical Society. The dedication and program was held on November 16, 2009, to not only commemorate the first settlement of Brecksville Township, but also to recognize the Paine family as the first settlers. (Courtesy of the Broadview Heights Historical Society.)

ON THE COVER: Lt. Chan Humphrey is driving with Capt. Ray Bender in the passenger seat of the Broadview Heights Fire Department's 1946 Dodge Pumper No 2. (Courtesy of the Broadview Heights Fire Department.)

IMAGES
of America

BROADVIEW HEIGHTS

Donald Faulhaber Jr.

ARCADIA
PUBLISHING

Published by Arcadia Publishing
Charleston, South Carolina

Printed in the United States of America

Library of Congress Control Number: 2015954375

For all general information, please contact Arcadia Publishing:
Telephone 843-853-2070
Fax 843-853-0044
E-mail sales@arcadiapublishing.com
For customer service and orders:
Toll-Free 1-888-313-2665

Visit us on the Internet at www.arcadiapublishing.com

*To the members of the Broadview Heights Historical
Society and residents of Broadview Heights who
provided pictures for this pictorial history*

CONTENTS

ACKNOWLEDGMENTS

The author wishes to thank the dedicated residents who started the official Broadview Heights Historical Society in 2001: Joe and Betty Behal, Ray Waibel, Candy Korn, Leo Bender, Lee Scholle, Shel Harper, and Jim Fahey; civic-minded residents Marie Bender and Hermine Merkle, who researched and saved the historical data of Broadview Heights for future generations; and the many citizens of Broadview Heights who saved pictures of their youth and the youth of our community so this book could tell the story of the past and how Broadview Heights developed as a wonderful place to live, work, and play. The majority of images in this volume appear courtesy of the Broadview Heights Historical Society (BHHS), the City of Broadview Heights (CBH), and the Faulhaber family (FF).

INTRODUCTION

Chippewa Heights, Seven Hills, and Broadview Heights were names considered for Broadview Heights when it became a village in 1927. The nickname "Highest of the Heights" fits the entire area. At 1,287 feet above sea level, it is the highest elevation in Cuyahoga County. The formation of Broadview Heights occurred after the end of the eight-year Revolutionary War in 1783, when Connecticut, a state of the new United States, found a good portion of their original land grant claimed by the states of New York and Pennsylvania. Connecticut gave up the claim for that area and took control of the remaining 120-mile strip renamed the Western Reserve. Included was all the land between the 41st and 42nd parallels, 120 miles westward from the Pennsylvania border. When this reserve land became available, the Connecticut Land Company, consisting of 25 buyers, purchased the entire area for 40¢ an acre or $1.2 million.

Ohio became the 17th state of the Union on March 1, 1803, followed by Cuyahoga becoming a county in 1807. A land grant from the Connecticut State Assembly, dated April 30, 1807, gave Col. John Breck of Northampton, Massachusetts, and his heirs authority to survey, allot, and sell 17,411 acres located west of the Cuyahoga River. This area now consists of three communities: Brecksville, Broadview Heights, and North Royalton. Colonel Breck contracted surveyor Seth Paine, allowing him to not only survey but also to act as land agent to sell parcels to other settlers. For his compensation, Paine was allowed to choose 200 acres located on the northeast corner of Broadview and Boston Roads, which is now Broadview Heights. Seth Paine's family, including wife Hanna, sons Oliver and Spencer, and daughters Almira and Lorena, became the first settlers in Brecksville Township in 1811.

Not long after their arrival, Seth and Hanna's oldest daughter, Almira, married Melzer Clark, and the couple built their own cabin across from her parents on the west side of Broadview Road, which would become Royalton Township in 1818. As such, they were the first settlers of Royalton Township. Life was not kind to Almira. She was widowed twice in a short time. After the death of her first husband, she married Lewis Carter and had three sons: Lorenzo, Henry A., and one who died in infancy. Then Lewis died, and she married Henry Bangs. This area is still known as Bangs Corners, and descendants of the Carter family continue to live on the property.

The War of 1812 discouraged travel and any other settlement for a while. The settlers were not only fearful to stay but also fearful to leave. The sound of the ship's cannons during the battle on Lake Erie caused them to pack up some belongings and move to the Peninsula settlement on the Cuyahoga River, which was thought to be a safer location. Folklore has it that Hanna Paine could not take her dishes with her, so she buried them in the woods for safekeeping but was unable to find them when she returned. The dishes are believed to still be buried on their original homesite. After the war with England, the settlers started to arrive again. In 1816, a group of citizens in the western half of Brecksville Township drew up a petition to split, and Royalton Township was officially formed on October 27, 1818. The "North" designation did not occur until late 1800s when a town in southern Ohio was found to have the same name as Royalton. As more land

was settled, the area remained fairly stable, developing town centers within each township. The boundary line between the two communities was first named Townline Road, now known as Broadview Road. The school districts from each community followed the same geographic area as the townships. This area became the outskirts for the two communities, and as township officials turned their attention inward for their own growth and development, Broadview landowners were neglected by both communities. The area remained rural, with farming and raising livestock as the main source of business and commerce.

For 116 years, Broadview Heights was part of Brecksville Township or North Royalton Township, sharing schools, road services, and police and fire protection. This is the primary reason why Broadview Heights has never been laid out or planned in an orderly fashion in the same manner as other Western Reserve towns with a town green and town center. Most services, such as groceries, farm supplies, and even cemeteries, were located in the central areas of each township. It is ironic that Broadview Road was the first to be settled but the last to develop. As the years passed and modern inventions (electricity, telegraph, telephone, and automobiles) arrived in the area, the townships' trustees voted to incorporate and become a village with their own mayor and council: Brecksville in 1921 and North Royalton in 1927. The area on the west side of Broadview Road was still called Royalton Township, and the area east of Broadview Road was called West Brecksville Township. Residents on both sides of the unincorporated area petitioned to hold an election, and on June 23, 1926, at the Avery Road schoolhouse, the majority approved the incorporation with the name of the new village to be called Chippewa Heights. This vote was short-lived, for a lawsuit was filed to annul the election, the primary fear being that, by incorporating, it would raise taxes. The election was overturned, and a new petition was circulated. On November 30, 1926, an affirmative vote of 101-7 was cast to incorporate and name the village Broadview Heights. In an organizational meeting held on December 26, 1926, Floyd Harris was elected as the first mayor, taking office in January 1927.

With images of the early days of Broadview Heights from its formation in 1927 through the 21st century, this book will show where the motto "Believe in Broadview Heights" brings forth the pride of city officials, organizations, and residents that truly make Broadview Heights the "Highest of the Heights."

One

IN THE BEGINNING

The earliest settlements of Brecksville and North Royalton were in the southernmost area of each township on Townline Road. Broadview Road, as it is now named, divided each township, with Brecksville to the east and Royalton to the west. Members of the Seth Paine family settled Brecksville Township in 1811 and Royalton Township in 1816. This entire area is now Broadview Heights. The hardwood trees of the heavily wooded terrain provided logs for homes, barns, and retail structures. Once the area was cleared, land was available to grow much needed crops. Farmers were able to take their produce by horse and wagon to sell in Cleveland. Numerous types of wildlife (bears, wolves, mountain lions, deer, and rattlesnakes) inhabited the area, making frontier life dangerous. Early settlers lost members of their families at young ages. Seth Paine died in 1815, leaving his oldest son, Spencer, to support the family at age 14. Settlers continued to arrive, seeking their fortune, but found hard work and farming went hand in hand rather than fame and fortune.

In 1829, a plank road was constructed from Walling Corners to the Cleveland city limits. With growth and increased population, the need for schools was realized, and around 1850, a stone building on the corner of Broadview and Avery Roads was registered as School District No. 8. Like other district schools, it was supported by subscription. Each child had to bring one-quarter of a cord of wood to heat the building, and families in default were charged $1. Schools were closed on Monday so the girls could help with the wash and boys could work on the farm. There were nine schools east of Broadview Road and seven west of the road in 1874. The following images show the farm life and early transportation to sell produce and just how difficult farming was in the late 1800s and early 1900s.

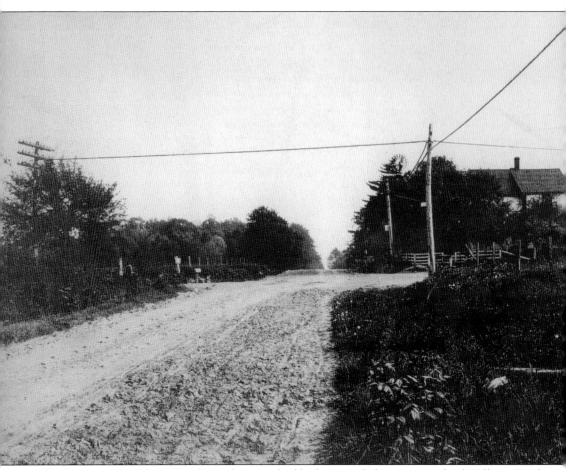

In this image, Broadview Road was photographed looking south from just north of Wallings Road around 1901. Buggy tracks can be seen in the gravel dirt road. The house to the right is the residence of Ransom Walling. Located on the same corner was a telegraph relay station; the wires are for telegraph service, not telephone. Looking farther down Broadview Road, there is a dirt mound with wagon tracks. A toll of 25¢ was charged to continue on Broadview, so a few enterprising drivers turned left onto Avery Road, bypassing the toll. (Courtesy of John Carvaines.)

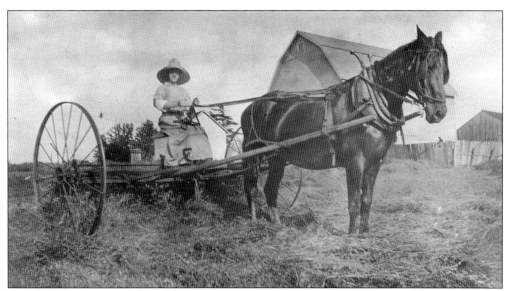

The Behal family moved onto the farm located on Broadview Road, north of Edgerton Road, in March 1902. Farm life was not an easy way to make a living, but with big families and everyone working together, food on the table and a house to provide shelter were always available. Daughter Victoria and the horse Lettie use a hay tender to turn over hay and put it into rows for loading onto a hayrack. (Courtesy of the Behal family.)

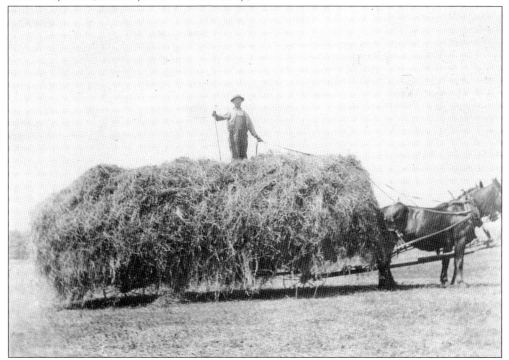

Once the hay was turned over and put into rows, Charlie was able to pile the hay onto the wagon, ready to thrash, unload, and store in the barn. Dry weather was needed for the cutting, turning, piling, and finally thrashing to have enough for the winter months. Rain would cause the hay to rot and become unusable. (Courtesy of the Behal family.)

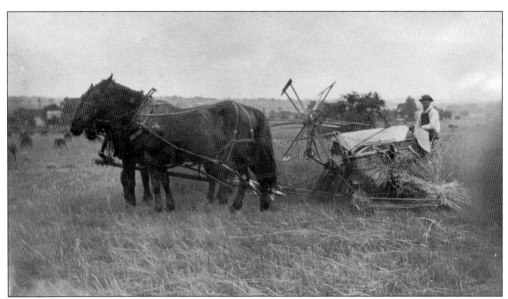

The only way to provide power on the farm was with a team of horses. Any type of power equipment was not available until after 1915. Life on the farm during harvest season consisted of long days spent working from sunrise to sunset, with a team of horses leading the way. Walking behind the team was a way of life. Grandson Joe Behal tells of a time when he was so tired that he rode the horse back to the barn at the end of the day. His dad saw him and told him in no uncertain terms to get off the horse because the horse had worked all day and needed rest for tomorrow's workday. It did not make a difference whether Joe was tired or not. (Courtesy of the Behal family.)

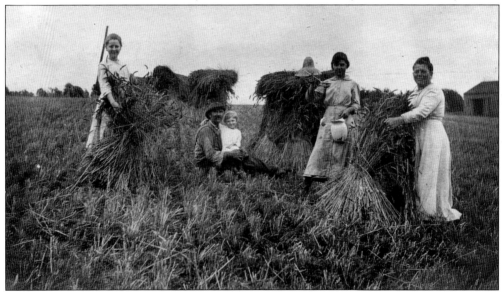

Shocking is a term used to describe the process of cutting, binding, and stacking the wheat in the field until dry and ready for thrashing. A person who performs this task is called a "shocker," while "shocking" is how the sheaves of wheat are placed together in the field. Shocking was a family project because it usually would take four to five people to complete a 10-acre field in a day. Anna, Pa, Margaret, Mame, and Ma are pictured in the field in July 1915. (Courtesy of the Behal family.)

Around the middle of July, the wheat was ripe and ready to be harvested, shocked, and left to dry in the field. When dry, the wheat was piled high on the wagon, waiting for thrashing and storage in the barn. Joe Bina and his helpers would bring his thrashing machine, along with 12–14 other farmers and farmhands. They went from farm to farm, finishing in September. Before leaving for the next farm, the ladies would have to feed them, usually roast beef, four chickens, mashed potatoes, gravy, homemade bread and butter, homemade pies, coffee, and some vegetables from the garden. No one was on a diet in those days. (Courtesy of the Behal family.)

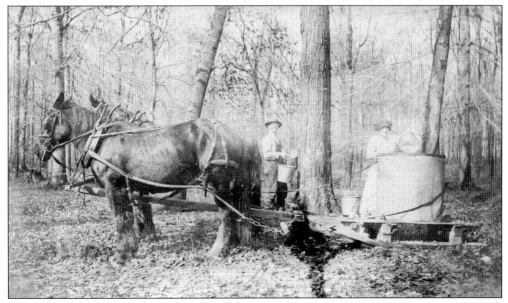

The Behal farm had a large number of maple trees, so it was a natural move to make maple syrup during early springtime. About 1,200 galvanized buckets where used to cook down 50 to 60 gallons of sap from the trees to make one gallon of maple syrup. (Courtesy of the Behal family.)

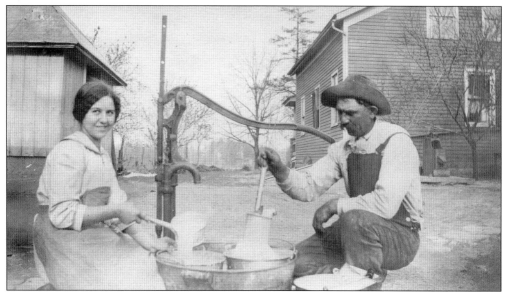

Mamie and Vaclav (Pa) are shown cooling milk. Every Wednesday, cream was churned to butter, then washed and placed in a tub of cold water. When chilled, the butter was weighed into one-and-a-half-pound wrappers. Thursdays at 4:00 a.m., Victoria, age 14 in 1907, traveled three hours to Cleveland to sell the butter and other seasonal fruit and vegetables. (Courtesy of the Behal family.)

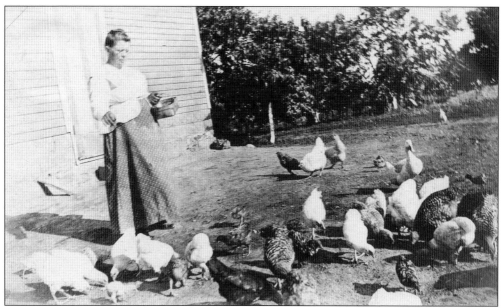

This image of Ma feeding the chickens shows the easy part of raising them, simply throwing feed in the yard. A few ducks also showed up to enjoy the bounty. Around 1911, an incubator was purchased, and it was Victoria's job to turn the 100 eggs every day, clean and fill the kerosene lamp, turn the wick, and make sure the temperature was set at 98 degrees. The incubator would hatch 65 to 80 chicks, while some sitting hens would provide a few dozen more. (Courtesy of the Behal family.)

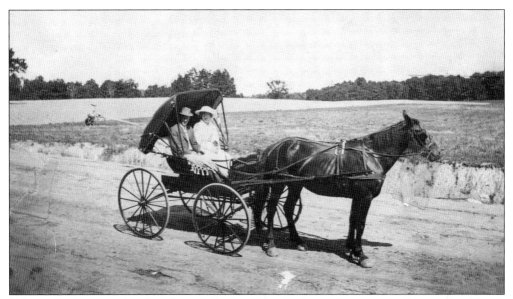

Life on the farm was hard work, and the family worked together to make it a success. Young men and women also had the opportunity to meet, and the courtship of Victoria started around 1913 with John Kleinpell of Avery and Royalton Roads. In this view facing east, the farmland that would become the Seneca Golf Course is seen beyond this couple taking a carriage ride on Broadview Road. This photograph was taken when John and Victoria got engaged in 1916. (Courtesy of the Behal family.)

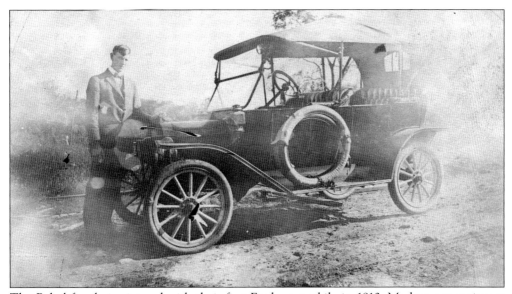

The Behal family is pictured with their first Ford automobile in 1913. Modern conveniences started arriving in the area around 1913, just before World War I. The farmers in the Broadview Heights area were the last to receive electricity, telephone, and other services, which needed to spread from each central township. Farm machinery became available as long as there was enough money to pay for them. (Courtesy of the Behal family.)

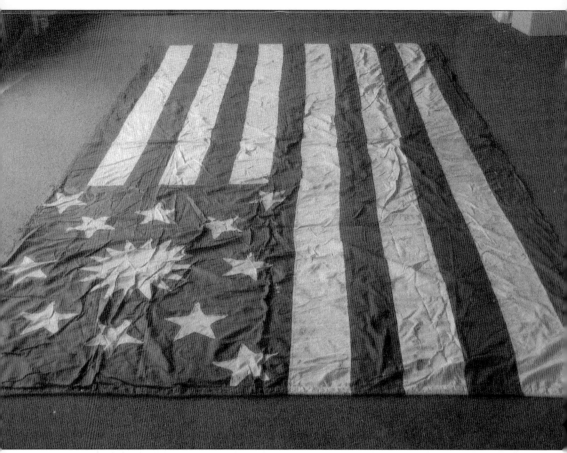

Ransom Walling purchased 25 acres on the southwest corner of Broadview and Walling Roads on February 24, 1855. Walling admired Pres. Abraham Lincoln and designed a flag in his honor in 1862. The ladies of the neighborhood who sewed the flag were Mrs. Burr Van Noate, Mrs. John Wyatt, Mrs. Fayete Wyatt, Mrs. Wyman, Mrs. Morgan, Mrs. Levi Booth, Mrs. Hogan, Mrs. Jane Wilcox, and Mrs. Frank Miner. Many of the women were the wives of original settlers, with roads, buildings, and schools named after them. While the women were sewing the flag, their husbands went into the woods and cut down a 100-foot tree to serve as a flagpole, which stood on the corner of Walling's property. There, the flag was raised every day and taken down every night as long as the Civil War lasted. In addition to the 13 stripes, the flag has 13 stars representing the original states, and the large central star has 16 points to signify Lincoln as the 16th president. The flag is 8 feet by 12 feet and is patterned similar to the American flag. The Brecksville Historical Association is currently in possession of the flag. (Courtesy of Brecksville Historical Association.)

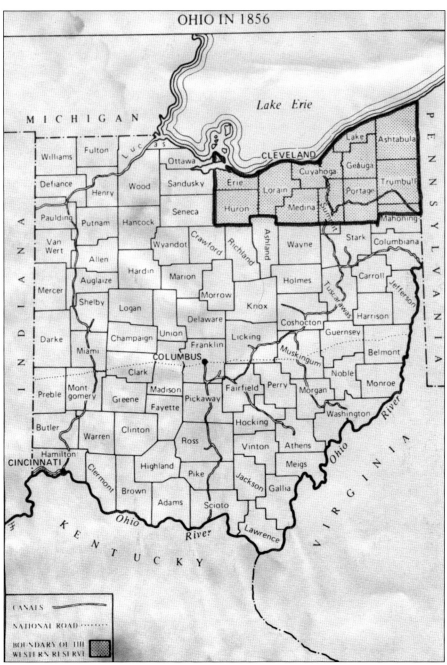

OHIO IN 1856

This 1856 map of Ohio shows the boundary lines of the Western Reserve, which includes the counties of Erie, Huron, Lorain, Medina, Cuyahoga, Portage, Geauga, Lake, Ashtabula, and Trumbull, as well as the northern parts of Summit and Mahoning. The dark lines represent the extensive canal system that provided supplies and produce to settlers from the Ohio River in the south to Lake Erie in the north. Remnants of canal locks are still visible in many areas of the state. The state of Ohio was becoming a popular place for migration to purchase land and settle in the "western" part of the United States. The true West was not ready for settlement until after the Civil War. (Courtesy of BHHS.)

17

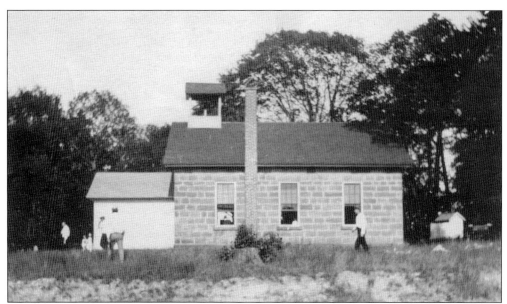

The Avery Road schoolhouse, shown here around 1912, was constructed of brick and stone in the triangle at the intersection of Avery and Broadview Roads around 1850. At the time, the roads were named Van Noate and Townline. The school was heated by a big box stove. The classroom was furnished with wooden benches along the wall and big wooden desks in front. A pail and tin dipper, a stool, dunce cap, and a large map on the wall rounded out the room. Using the *National Reader*, the children were taught to read in unison. This school, along with other district schools, closed when the central school was opened in the center of Brecksville in 1915. (Courtesy of the Harris family.)

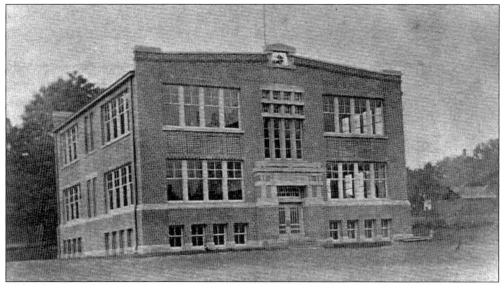

Once the central school was ready in 1915, the question became how to find enough students to fill this eight-room building. The lower four rooms were used for the elementary children, and with the closing of the nine district buildings, all rooms of the central school were soon filled to capacity. After many additions, this building is still in use and just celebrated its 100-year anniversary. (Courtesy of BHHS.)

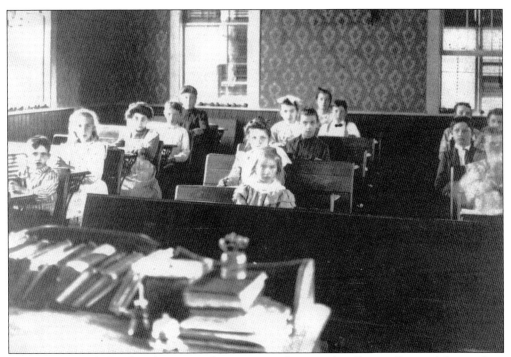

Children sit ready for their lessons in the one-room district schoolhouse. Some of the teachers were Mary Frazee, Mary Wyatt, Albert Aikens, Harley Miller, Frank Wilcox, Sarah Starr, Mary Clark, Marie Bratton, Cullen Wilcox, and Ella Van Noate. (Courtesy of BHHS.)

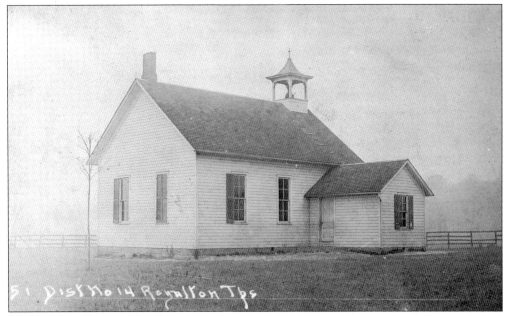

The Royalton District School was located on the Behal farm on Edgerton Road. The family had donated an acre of land for the district school. The school bell is still in the custody of the Behal family. (Courtesy of the Behal family.)

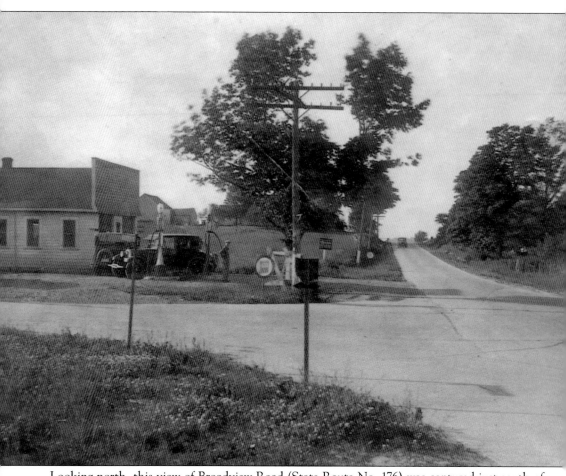

Looking north, this view of Broadview Road (State Route No. 176) was captured just south of Royalton Road (State Route No. 82) in 1923. This first Texaco station on the Cunningham homestead was located halfway between the center of Brecksville and Royalton Townships. John Cunningham was the second mayor of Broadview Heights, serving from 1930 to 1934. (Courtesy of the Cunningham family.)

Two

THE EARLY YEARS

The early years of Broadview Heights started with a vote held at Jake's Barbershop on the corner of Broadview and Wallings Roads on November 30, 1926. The results were 101-7 in favor of incorporating as the village of Broadview Heights. The first council meeting was held on January 13, 1927, and the following officials, duly elected, were sworn in by justice of the peace Arthur Luempert: mayor Floyd G. Harris, clerk Carl A. Burtcher, treasurer Fred G. Clogg, marshal Lloyd Harris, and councilmen Charles Behal, A.N. Fuchs, Joe Fuchs, Frank Masek, Frank Valvoda, and S.J. Gynn.

On April 2, 1928, Mayor Floyd Harris called a public meeting to discuss the selection of a town hall site. The assembled citizens all agreed the hall should be situated in the center of town at the corner of Broadview and Royalwood Roads. Ordinance No. 34 directing the issuance of bonds in the sum of $26,000 for the purchase of land and construction of a town hall was approved. The completion and dedication was held on Saturday, July 27, 1929.

During the Depression years and World War II, there were not many new residents. The new village struggled to provide services for the community. In 1939–1940, the US government built a hospital on the former Waibel farm on the southeast corner of Broadview and Oakes Roads, providing medical aid for wounded veterans. Other services such as civil defense and fire and police protection were not established until during the war. Growth and population increases started in the late 1940s and early 1950s. The time had arrived for the residents of the Broadview Road area to take control of their future and establish the community that is now Broadview Heights.

The first mayor of Broadview Heights was Floyd Harris, seen here in his high school graduation picture. Harris was born in 1887 and died in 1937 at the age of 50. He married Rilla Hecker, Riley Hecker's sister. In most small close-knit towns, families became related to each other through marriage, resulting in a nearby extended family. As the story of Broadview Heights expands, there will be reference to residents and how they connect to one another. Floyd Harris and Lloyd Harris, the first marshal of Broadview Heights, were brothers. Floyd worked as a motorman for the Cleveland Transit System. (Courtesy of the Harris family.)

Dedication Program

BROADVIEW HEIGHTS VILLAGE HALL

Saturday, July 27th, 1929

The dedication of the new Broadview Heights town hall took place on Saturday, July 27, 1929. The ceremony was a festive occasion featuring opening remarks from Mayor Floyd Harris, followed by Broadview Heights serenaders Albert A. Lorenzen, Harold C. Lorenzen, and John Mazinek and an address by Cuyahoga County sheriff Edward J. Hanratty and the Cleveland Radio Girls, Merry and Glad Morgan. Tom Hamley's Entertainers provided music for dancing the night away. Councilmen John P. Cunningham and Frank Zirna, along with new marshal Frank Sefcik, were appointed and took office in January 1929. (Courtesy of BHHS.)

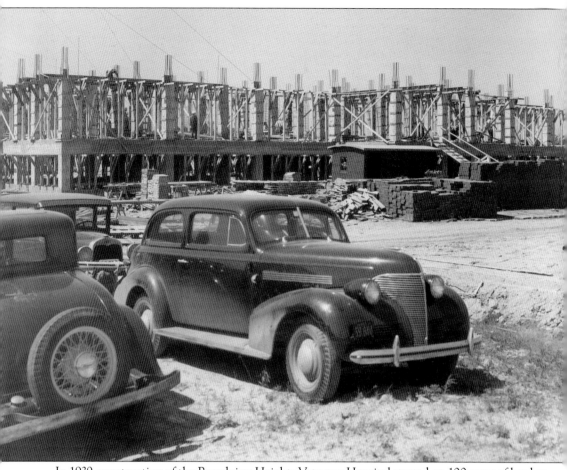

In 1939, construction of the Broadview Heights Veterans Hospital started on 100 acres of land on the southeast corner of Broadview and Oakes Roads, where the Waibel family once farmed. The Waibel family worked the land from the early 1900s until high taxes from the paving of Broadview Road in 1938 forced them to sell to the City of Cleveland. They leased the land back for $1 per year until the US government purchased the property and constructed a 269-bed veterans' hospital at a cost of $1 million. Other structures included nurses' and attendants' quarters, garage, boiler house, and warehouse. (Courtesy of BHHS.)

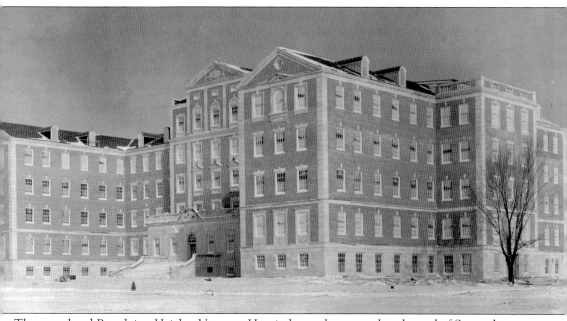

The completed Broadview Heights Veterans Hospital complex opened at the end of September 1940. The new area was described as one of the largest and most beautiful places in which to recover. A newspaper quote in the Cleveland *Plain Dealer* announced the opening of the hospital: "Situated on higher ground offering a view from any window should be a boon for the ailing veterans away from the confusion, unrest and worry of a city. The air is pure." The Waibel family was able to move their large farmhouse directly across the street to the north side of Oakes Road and split it into three separate homes. The regional offices of the Veterans Administration were moved to the main hospital building. (Courtesy of BHHS.)

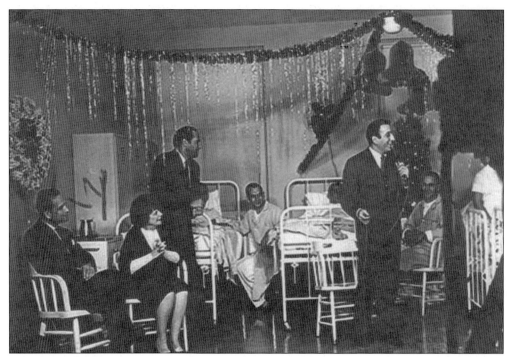

Dorothy Fuldheim, newswoman and commentator, is seated on the left with singer Tony Bennett, entertaining the servicemen during their recovery. Dorothy had a history of writing, acting, and appearing on radio and, later, television. In 1947, the 54-year-old signed on with Cleveland News Channel 5 WEWS for a 13-week trial run. Her commentary segment in which she interviewed presidents, popes, kings, queens, and movie stars ran after the news for 17 years. It was her down-to-earth appeal that her fans, and critics, loved. (Courtesy of BHHS.)

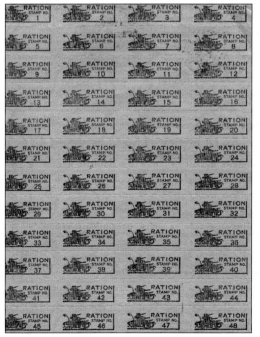

War ration books were issued to individuals during World War II to control the inventory of various items in the United States so the armed forces would have a sufficient supply. On the cover of each ration book was an individual's control number, along with his or her address, age, sex, weight, height, and occupation. Each stamp authorized the purchase of rationed goods at specific quantities and times, as designated by the Office of Price Administration. No one was able to purchase those goods without the stamps. Ration items included butter, meat, cheese, sugar, shoes, gasoline, tires, and fuel, to name a few. All residents were encouraged to give their whole support to rationing, guided by the rule "If you don't need it, DON'T BUY IT." (Courtesy of FF.)

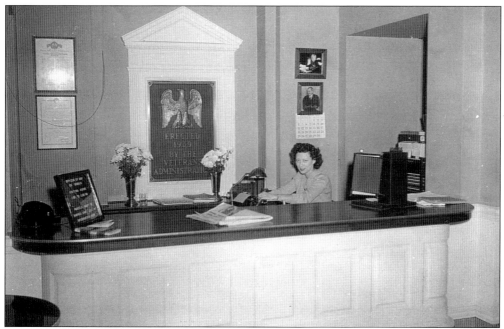

Glenneth Snow is pictured in the lobby of the Broadview Heights Veterans Hospital, where she worked as a receptionist. The plaque with the eagle shows the Veterans Administration (VA) constructed the building in 1939. (Courtesy of the Snow family.)

The attendants' building is the only one still standing from the original Broadview Heights Veterans Hospital complex, and once remodeling is finished, it will be the new home of the Broadview Heights Historical Society. (Courtesy of BHHS.)

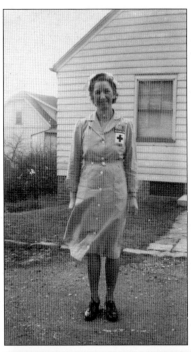

Rozetta Scheuerman, a dietician's aide, worked at the VA hospital during World War II. Rozetta and her husband, William, were extremely active in Broadview Heights in the early days. She was not only a dietician's aide, but also the air raid warden for the area. Their house was the location for War Bond Sales and the Red Cross Blood Bank, as well as the meeting place for the start of new organizations, such as the Broadview Heights Chamber of Commerce, Dogwood Garden Club, and Blue Star Mothers. (Courtesy of FF.)

Eileen Harris (far right) and other employees of the Western Electric Company, a manufacturer of telephone parts, are shown at work during World War II. Standing in the back are Theo B. Buffington and Florence Balala. At the front are stockroom clerks Marge Pfaff (left) and Betty Ostay. (Courtesy of the Harris family.)

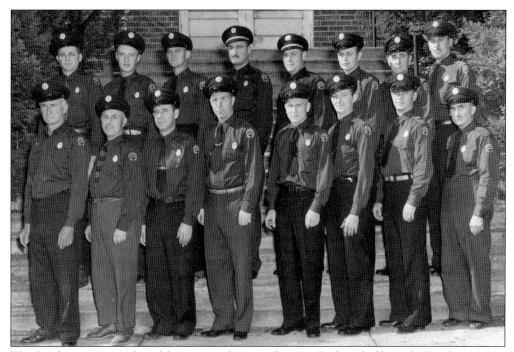

The fire department gathered for a group photograph in 1945. Identified by only their last names, from left to right are (first row) Fuchs, Hammond, Perzy, Perram, Curtis, Benyak, Vlcek, and Stedronsky; (second row) Mattern, Alesnik, Hovancsek, Chief Loeffler, Captain Bender, Yarian, Marria, and Minich. The Broadview Heights Volunteer Fire Department was organized in September 1942 as auxiliary firefighters under the Office of Civilian Defense. After completing an extensive training course with chief fire warden Floyd Meek, the men were certified as volunteer firefighters and accepted by the Ohio Inspection Bureau. (Courtesy of BHHS.)

In March 1943, the US government loaned the village a trailer pumper and equipment. Two years later, the men had contributed more than 1,500 hours protecting the village and responding to 18 fire calls. (Courtesy of BHHS.)

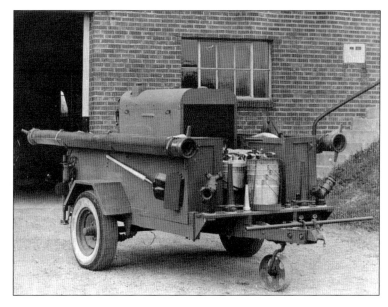

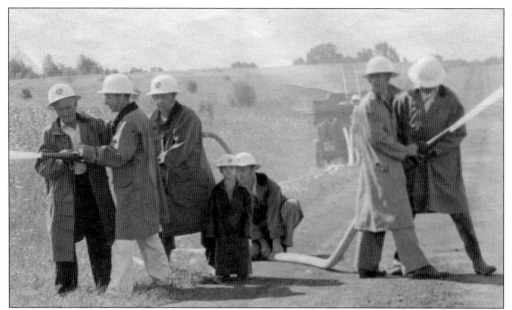

Training on new equipment, or what was new to the village, was extremely important practice. During the week, firefighters met to practice all aspects of fire training. Here, the men are testing the new trailer pumper with their own little mascot. (Courtesy of BHHS.)

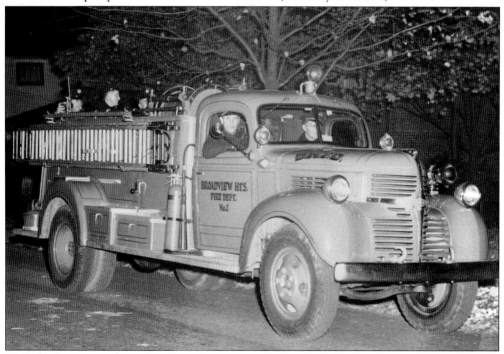

With the formation of Broadview Heights Fire Department in September 1942 and the population increase of the village by 1945, new fire equipment was needed; the first being a 500–gallons per minute pumper with a 150-gallon tank, and the second largely a tank truck to supply water to remote areas of the village. These two trucks and the 20-member department helped reduce insurance rates up to 50 percent in some areas. (Courtesy of Broadview Heights Fire Department.)

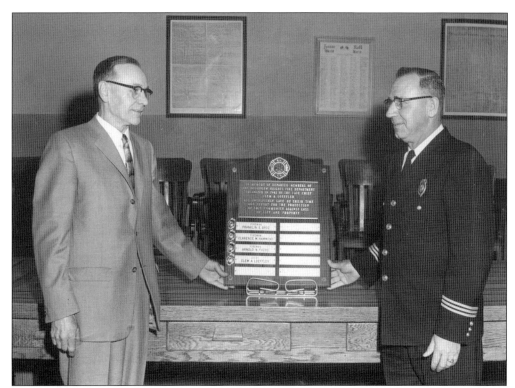

Mayor Arthur Leumpert and fire chief Fred Perzy presented this plaque to the city in 1958, honoring the deceased members of the fire department. The plaque reads, "In memory of departed members of the Broadview Heights Fire Department organized in 1942 by the late Chief Clem A. Loffler. All unselfishly gave of their time and effort for the protection of this community against loss of life and property." Four men are listed as deceased at the time of this presentation: firefighters Franklin E. Broz, Clarence M. Hammond, and Arnold N. Fuchs and Chief Clem A. Loeffler. (Courtesy of BHHS.)

Ordinance No. 34 authorized the building of the first town hall in 1928. The site selected was centrally located on the northwest corner of Broadview and Royalwood Roads. The facility was completed and dedicated in July 1929. The hall was remodeled in 1973 and used until the move to the new city hall complex in 1999. (Courtesy of the Harris family.)

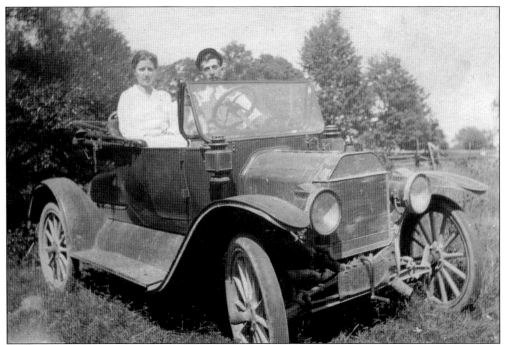

Mayor Floyd Harris and his wife, Rilla, take the family car out for a spin. The automobile, a "new contraption," as many people called it, was not available to the common workingman until Henry Ford developed the assembly line in the late 1920s and was able to produce cars in one style and a choice of any color as long as it was black. (Courtesy of the Harris family.)

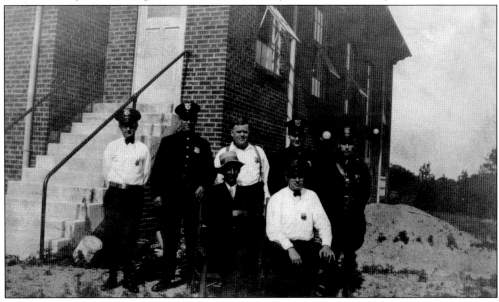

Pictured around 1930 from left to right are (first row) Mayor Floyd Harris and police chief Frank Sefcik (second row) Joseph Hovansek, Riley Hecker, unidentified, Elmer Brownlee, and Charles McCreery. Sefcik was chief from 1929 until his death on June 28, 1954. His 25 years as chief is still the longest period of any chief in the history of Broadview Heights. (Courtesy of the Harris family.)

At right is Riley Hecker, brother-in-law of Mayor Harris. Riley's sister Rilla was the wife of Mayor Harris. Riley was not only a policeman in the new village, but also the owner of a produce gas station on the southeast corner of Route 82 and Broadview Road. This building was moved around the corner onto Broadview Road in the late 1950s. There, it was remodeled and is still in use today as Loede's Famous Reuben Deli. (Courtesy of the Harris family.)

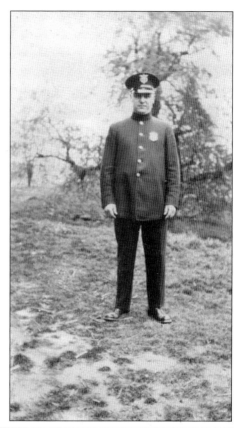

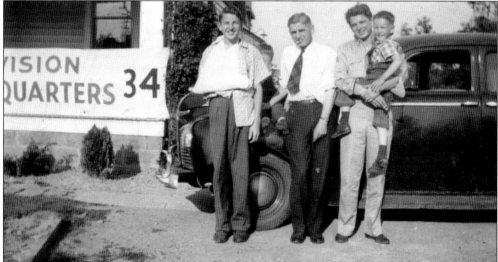

During World War II, the Scheuerman family home was Division 34 headquarters, providing war bonds and ration stamps distribution. It was also the meeting area for the Red Cross and the newly formed chamber of commerce, Blue Star Mothers Club, and others. William P. Scheuerman (wearing a tie), the first president of the chamber of commerce and vice president of the Brecksville School Board, is pictured on June 15, 1945, along with his sons Robert (left) and Bill (right), holding Donald Faulhaber Jr. (Courtesy of FF.)

Mayor Floyd Harris poses with wife Rilla and daughter Eileen in front of Oaks Barbecue around 1929. The restaurant was around the corner from the Harris house, so Floyd and his family were able to walk there and socialize with their neighbors. He became well acquainted with fellow voters, which helped him get elected as the first mayor of Broadview Heights. (Courtesy of the Harris family.)

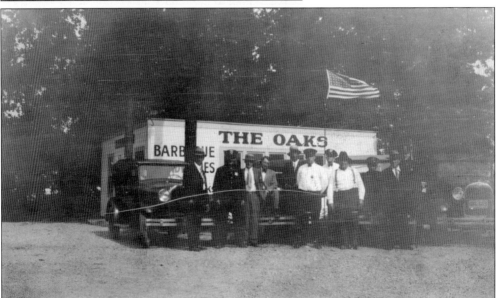

Oaks Barbecue, located on the corner of Broadview and Avery Roads, was a popular place in the early days of Broadview Heights for people to gather and spread the news of the day. (Courtesy of the Harris family.)

Broadview Heating owner Carl Olecki purchased the old Texaco gas station property on the northwest corner of Broadview and Royalton Roads in 1984. This is the same station and corner as pictured on page 20. Stan Dostal, Tom Born, and George Paryzek started Broadview Heating in 1947. They sold the business to Frank Resnick, who then sold to the Olecki family in 1960. It is the oldest business in Broadview Heights. (Courtesy of the Olecki family.)

THE IDEA FOR A CHAMBER OF COMMERCE
STARTED WITH A CHALLENGE IN NOVEMBER 1943

BROADVIEW HEIGHTS VILLAGE
HOME FRONT ACTIVITIES

2nd Issue page 1 November 1943

BROADVIEW HEIGHTS TO HAVE
A CIVIC ORGANIZATION?

This statement is made in the form of a question. It can, however, be a certainty if proper backing by the men in the village can be had at its first regular monthly meeting scheduled Nov. 15. Its purpose and aims, while broad, are primarily to be directed for the improvement and betterment of Broadview Heights.

WE NEED and CAN HAVE such an organization -- for by it, and through it, as a community we could achieve our place in this end of the county, and not be continually known as that part of Cuyahoga County that adjoins the better known Brecksville and North Royalton Villages.

There are a thousand and one reasons why we should have such a Civic group.

MEN of Broadview Heights -- lets CAPITOLIZE on our ASSETS, - We have assets you know, they are what attracted us out here, to enumerate just a few:- We have more miles of city water on our streets than adjoining villages. We have a fairly low tax rate, (much lower than Cleveland). We have good paved roads. We are in one of the most beautiful parts of Cuyahoga County. We are the home of U. S. Veterans Hospital. We have miles of healthy scenic countryside.

We have many more things to be proud of, lets keep them and improve on them whenever possible. This can only be done by acting as a unit, through an organized group of civic minded residents.

MEN, be a part of such a group. ALL MEN ARE CORDIALLY INVITED remember the date Monday, November 15, 1943 at the Town Hall.

⸢ ⸥

THIRD WAR LOAN DRIVE
FINAL RESULTS

Broadview Heights Village had as our quota the amount of -- $26,000.00

Thanks to our hard working Bondadieres, the returns were as follows:--

Team No.	Individual sales	Amt.
1	102	$7,800.00
2	45	4,050.00
3	65	4,525.00
4	85	20,125.00
Veterans Hospital	456	19,500.00
TOTAL	753	$56,000.00

W. A. C.

By proclamation of the Governor of Ohio: the cities and villages are asked to recruit women to replace all men in noncombat duty through the WAC's organization.

The State of Ohio has been assigned a quota of 3,165 members to be recruited, our village will be expected to furnish its share. For this purpose, Mayor Luempert has appointed a committee of three, Mrs. W. P. Scheuerman, as chairman; and her daughter, Mrs. D. A. Faulhaber, either may be reached at Brecksville 3175; and Mrs. Vlasta Kouba, who may be reached at Brecksville 4103.

If interested, please call for information.

RATION SCHEDULE
Brown stamps H valid Oct. 31st
I valid Nov. 7th
expire December 4th.

Blue stamps X - Y - Z are good through November 20th.
Stamps A - B - C in Book 4, good November 1st through December 20.

⸢ ⸥

In November 1943, the front page of the second issue of the original Broadview Heights *Village Home Front Activities* newspaper called for the formation of a civic organization. According to the editorial, there were a thousand and one reasons why Broadview Heights should have such a civic group. (Courtesy of FF.)

Chamber of Commerce

The December meeting of the new Broadview Heights Chamber of Commerce was well attended in spite of near zero temperature. Permanent officers for the year 1944 were elected as follows:

President	Wm. Scheuerman
V. Pres.	Emil Cotleur
Secretary	Robert Yarian
Treasurer	Raymond Bender

In addition the charter, under which the Chamber will operate, was discussed and adopted. Its adoption brought to light a good many ideas and options which were, at times, rather warmly discussed; but a spirit of complete harmony prevailed at all times. This augers well for the future of the organization, as it means they have the ability to discuss freely and completely any and all controversial subjects without upsetting the very necessary equilibrium and balance that a group such as this needs.

The Chamber of Commerce feels our community needs such a body of men. And we feel you will enjoy the association with such a group. Membership is now open to all male residents of the Village of Broadview Heights who are over 18 years of age, or over. Annual dues are $1.00 per year. Meetings are to be monthly, on the Tuesday following the second Monday of each month.

Next meeting is Tuesday, January 11, at the Village Town Hall. Come and join us.

Thanks were extended to the Charter Committee, Messers Green, Klein, and Atty. Beckett who not only gave generously of his time and experience, but stayed on to become a valued member.

E.J. Cotleur, Publicity Chairman

The Broadview Heights Chamber of Commerce started in January 1944 with newly elected officers and an agenda for the improvement and betterment of Broadview Heights. (Courtesy of FF.)

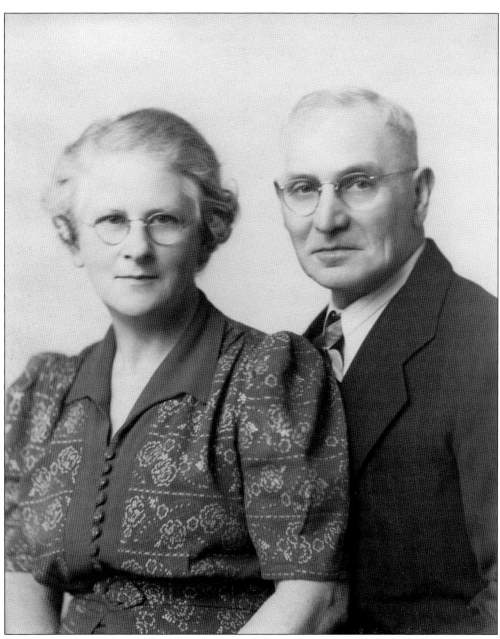

Jacob "Jake" Trapp is pictured in this portrait with his wife, Rose. Trapp had a barbershop at the corner of Wallings and Broadview Roads, where the original meetings to incorporate the community were held in 1926. The official vote, which passed 101-7 to become a village, was also conducted at his barbershop. As in most small towns across America, local news was not broadcast over the airways in the early days of Broadview Heights, so finding out the happenings in the newly formed village required personal contact. The Oaks Barbecue, Cunningham's Restaurant, or Jake's Barber Shop were the places where people gathered to catch up on community events, conduct business, or just relax and talk with friends and neighbors. (Courtesy of the Trapp family.)

Jacob Trapp enjoyed fishing and taking his granddaughter Barb with him to Hinckley Lake. Here, he shows off the catch of the day. (Courtesy of the Trapp family.)

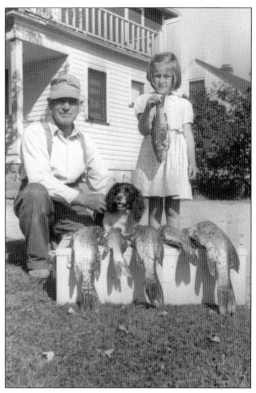

Rose Trapp loved animals. Their small farm had numerous cats, one cow, many chickens, and only one dog at a time. (Courtesy of the Trapp family.)

Lawrence Trapp, Jake and Rose's son, drove this Pontiac business coupe. The car was normally used for deliveries because it was good on gas and easy to park. Members of the family believe Lawrence, who graduated from Brecksville High School in 1933, just used it for back-and-forth commuting to work. (Courtesy of the Trapp family.)

Broadview Heights was primarily a farming community when it was founded. Large tracts of 40–100 acres were the norm for early settlers. Jake and Rose Trapp had a small parcel with mostly typical gardens, planted for use in their home, not to sell on the open market. The field can be seen in the upper-right corner of the picture. The animals were chickens, a cow, and cats and dogs, which were allowed to run free in the neighborhood. The dogs were more curious than menacing when a stranger approached. (Courtesy of the Trapp family.)

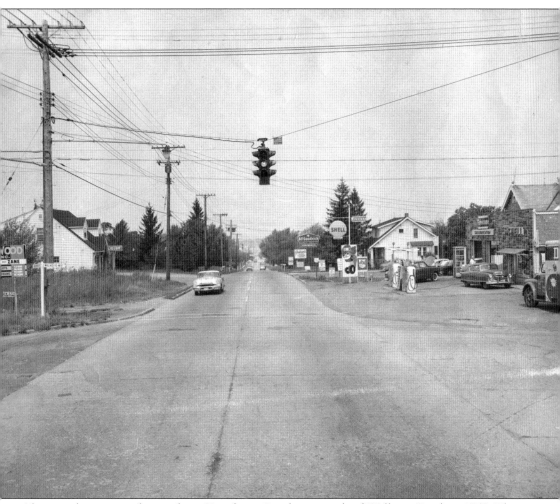

Above is the view to the north on Broadview Road, just south of Wallings Road, in 1958. The original buildings from the 1920s were still standing. Knapp's Villa is on the left, and the Clogg house is on the far right, along with Burton's Shell station and Gunner's IGA market. Broadview Road was soon widened to four lanes from Avery Road north to Sprague Road. (Courtesy of BHHS.)

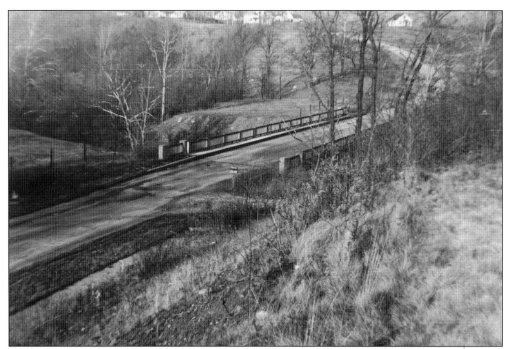

Mayor Arthur Luempert persuaded the Cuyahoga County commissioners to construct a bridge in early 1934–1935 on Avery Road over Chippewa Creek to help with increased car and truck traffic. This creek crossing would flood, making traveling difficult on Avery Road. (Courtesy of the Woelfl family.)

Constructing a steel bridge on Avery Road over Chippewa Creek and raising the roadway a few feet opened the view looking north and furthered development along Avery Road. (Courtesy of the Woelfl family.)

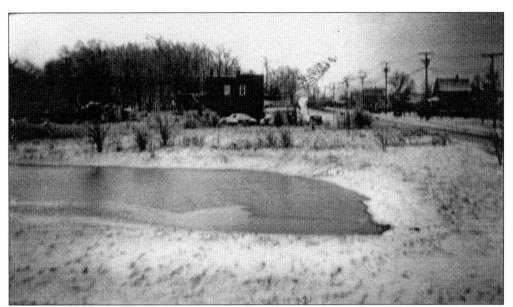

During the late 1940s and early 1950s, the fire department would flood the vacant lot on the southeast corner of Broadview and Wallings Roads. Kids of all ages would come and skate or just gather by the fire and watch the fun. (Courtesy of the Gunner family.)

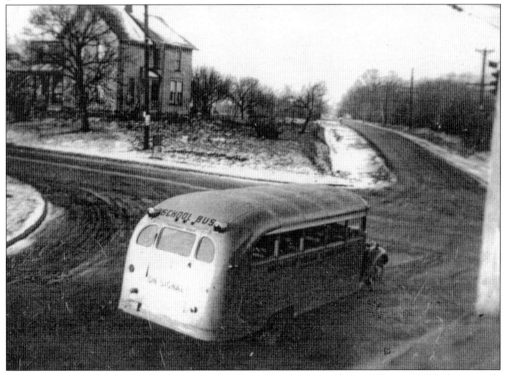

Above is a school bus heading west on Wallings Road at Broadview. This c. 1955 photograph shows the Walling homestead, which was torn down shortly after to make room for a gas station. Today, on that corner, the Stout family owns and operates the Fuerst Automobile Repair Shop. (Courtesy of the Gunner family.)

Prior to this photograph taken in 1987, the Avery Road schoolhouse had been abandoned and left in disrepair, as seen here just before it was torn down. The stones from the building were saved in hopes of reconstructing the schoolhouse as a living museum of early education. (Courtesy of the Ziebert family.)

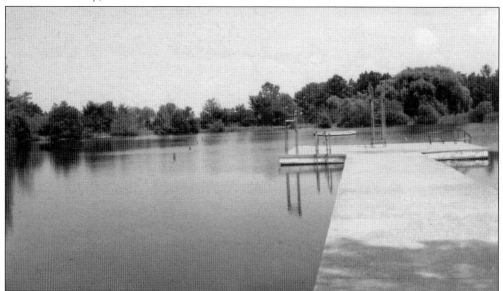

Chester and Dorothy Deyling built this swimming platform on Broadview Lake in the 1960s. The lake and picnic area was a popular and inexpensive place to have family gatherings. Anyone who could swim out to the raft, shown here just beyond the dock, was considered "the best." The Deylings opened the Dorchester Restaurant, which was also a popular gathering place. Today, the Country Lakes Party Center occupies the restaurant, and a housing development surrounds the lake. (Courtesy of the Ziebert family.)

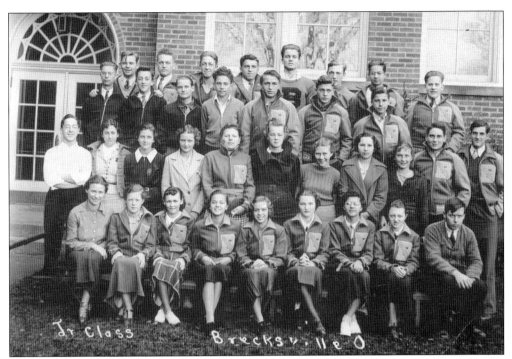

Pictured above is the 1937 junior class of Brecksville High School. All grades were housed in the central school. The high school and junior high school are now located in Broadview Heights, and the schools are known as the Brecksville–Broadview Heights City School District. (Courtesy of FF.)

Broadview Heights Body and Fender Repair, owned by Charles Koneval, was located at 8047 Broadview Road. When he first opened the repair shop, Koneval worked full-time in addition to raising about 300 chickens, which he sold, along with their eggs, to his fellow workers. He was also a member of the Broadview Heights Fire Department. (Courtesy of the Koneval family.)

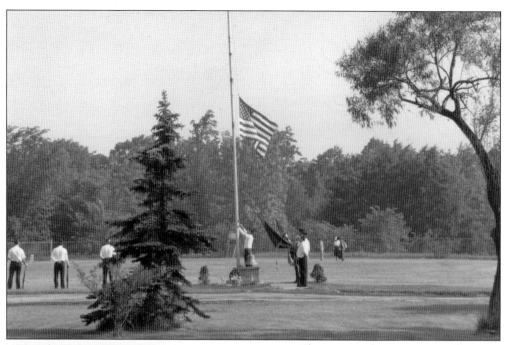

The Memorial Day flag-raising ceremony took place at American Legion Post No. 196 in 1970. This tradition was started shortly after the end of World War II and has been practiced every year since to honor all veterans on Memorial Day. For the past 30 years, the event has kicked off with a parade, including bands, floats, and various organizations participating. (Courtesy of the Markle family.)

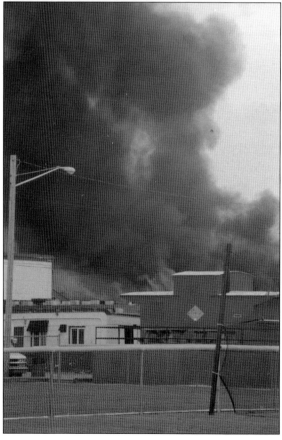

Neighbors George and Sylvia Markle, who lived across the street from the community park, took this picture of a service garage fire in 2003. They thought the caboose, which was used as a refreshment stand, was on fire, but it turned out to be the service garage. (Courtesy of the Markle family.)

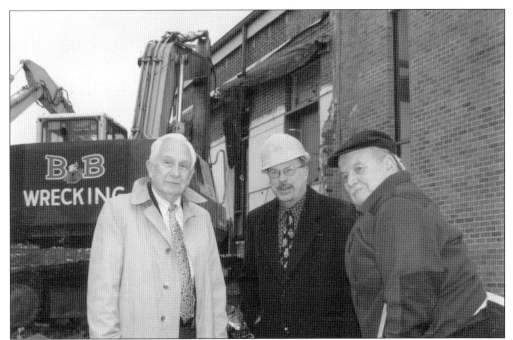

The original town hall, which served the community for over 70 years, was deemed too costly to renovate and repair, thus was torn down in December 2000. From left to right are Mayor Leo Bender, service director Ray Mack, and former mayor Donald A. Faulhaber. (Courtesy of FF.)

The entrance to the new city hall complex was named in honor of Leo H. Bender. In 1996, during his term as mayor, Bender initiated and successfully accomplished the purchase of 68 acres and all buildings from the State of Ohio to be used for the common good of the citizens of Broadview Heights. (Courtesy of CBH.)

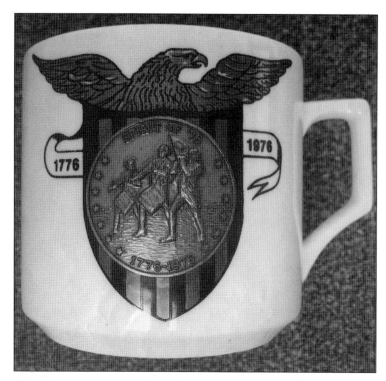

This commemorative coin mug was sold throughout the United States to celebrate the country's bicentennial in 1976. Great craftsmen produced this white porcelain mug, designed with 23-karat gold as a backdrop for the gold coin created by renowned numismatic artist Louis Martini. (Courtesy of the Walker family.)

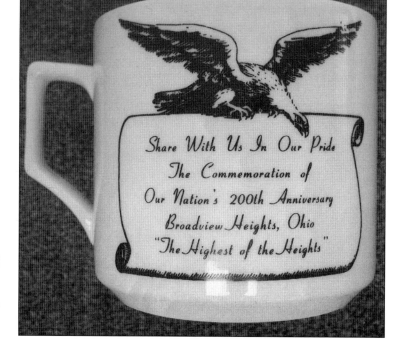

The city of Broadview Heights showed its pride by offering this commemorative mug as a souvenir of the 200th anniversary of the United States. (Courtesy of the Walker family.)

AM radio station WGAR signed on the air on December 15, 1930. The transmitter, broadcast studio, and business office were located in Broadview Heights until a transfer of ownership combined a number of local stations into one big broadcast location in the 1990s. The transmitter and broadcast studio still stand, and the station is now known as WHKW 1220, The Word. (Courtesy of FF.)

The annual meeting of WGAR management always included the mayors from surrounding communities. Pictured around 1975 are, from left to right, Broadview Heights mayor Donald A. Faulhaber, Strongsville mayor Dale Finley, an unidentified WGAR executive, disc jockey Joe Mayer, Brecksville mayor Jack Hruby, and North Royalton mayor Harry Loder. (Courtesy of FF.)

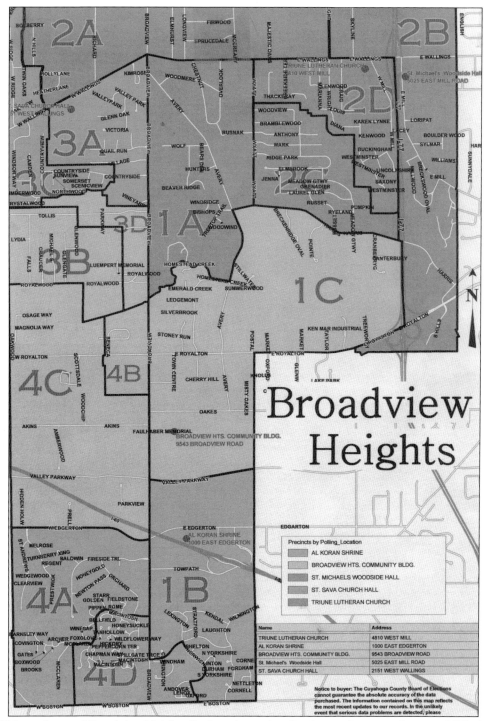

This ward map of Broadview Heights displays the voting districts as they were drawn in 2012. As in all communities, in order to create population equality, the wards are not necessarily contiguous to one another. Broadview Heights City Council consists of four ward council persons and three at-large council persons. (Courtesy of CBH.)

Three

PEOPLE AND
ORGANIZATIONS

Broadview Heights has always been a close-knit community, with descendants of the original founding families still involved in service and civic organizations. Together, the Jaycees, Kiwanis, Lions, Rotary, and Blue Star Mothers Clubs, along with the local chamber of commerce, garden clubs, and political groups, assisted the less fortunate and helped to improve the area. In November 1943, the newly formed *Village Home Front News* put out a call to all civic-minded men of the community to "CAPITALIZE on our ASSETS" and form a civic organization that, as a united group, would be directed for the improvement and betterment of Broadview Heights. In January 1944, the new Broadview Heights Chamber of Commerce performed the installation of the following officers: William P. Scheuerman, president; Emil Cotleur, vice president; Robert Yarian, secretary; and Raymond Bender, treasurer. The very first guest speaker was Judge Edwin Blythin, president of the Cleveland City Club, who would go on to be the judge in the illustrious Dr. Sam Sheppard murder trial in 1954. The chamber is still active today, celebrating over 70 years of community improvement.

Also in 1944, the Blue Star Mothers Club, Dogwood Garden Club, and Broadview Heights Volunteer Fire Department were formed. Committees were set up to establish Boy Scout troops, Little League teams, neighborhood picnics, and athletic activities within the community. The 1950 census marked an increase in population and, with the building boom of the 1950s, the desirability of Broadview Heights as a place to call home. Farmers found the cost of property taxes too expensive to maintain their farms, so their land was converted to residential development. Those responsible for this growth and eventual achievement of city status in 1961 were from some of the original settling families of Broadview Heights. In a city with a population of over 5,000, they were extremely proud of what they had accomplished.

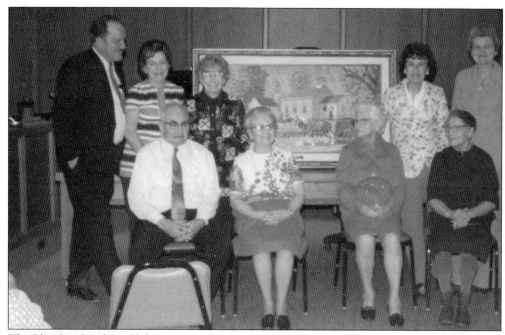

The Blue Star Mothers Club came into existence during World War II with Rozetta Scheuerman as president. These mothers of sons in the military kept tabs on all servicemen from Broadview Heights, sending them cards and gifts on special occasions and holidays. A blue star was placed in a window of each home to signify that a military family lived there. If a son was lost in battle, the blue star was exchanged for a gold star. Only three members, president Rose Rezabek, secretary Alma Hauth, and treasurer Helen Kulczycki, remained when the club dissolved on March 27, 1974. The money left in the treasury was used to commission an oil painting of the original Avery Road schoolhouse by North Royalton artist Woody Henry. In March 1974, the painting was presented for safekeeping to Mayor Donald A. Faulhaber, along with all the Blue Star Mothers Club's records, which are now entrusted to the Broadview Heights Historical Society. From left to right are (first row) former students Clarence Hennis, Elva Valvoda, Rose Trapp, and teacher Elsie Hecker; (second row) Mayor Donald A. Faulhaber, Helen Kulczycki, Rozetta Scheuerman, Rose Rezabek, and Alma Hauth. (Courtesy of BHHS.)

Members of the Dogwood Garden Club pose for a photograph. From left to right are Gertrude Storgard, president; Louise Duff, secretary; Patricia Kolina, treasurer; Alberta West, first vice president; Adele Paul, second vice president; and Wanda Luzius, corresponding secretary. The organization was started in 1944 and met monthly in members' homes until the late 1970s, when interest waned and the club folded after 35 years. (Courtesy of BHHS.)

The Broadview Heights youth soccer B team, ages 13 to 15, won the Lake Erie Junior Soccer League championship in 1970. Pictured with coach Phil Seil (kneeling with the trophy) are, from left to right, (first row) Dave Karakas, Steve Osmond, Tony George, Kent Johnson, and Brent Nixon; (second row) Allen Jefferis, Tim Jacobs, Terry Truchan, Jeff Smola, Bob James, Randy Miller, Ray Karoly, Mike Chojnicki, and Charlie Ayala. (Courtesy of the Seil family.)

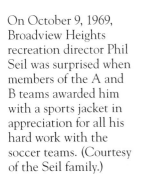

On October 9, 1969, Broadview Heights recreation director Phil Seil was surprised when members of the A and B teams awarded him with a sports jacket in appreciation for all his hard work with the soccer teams. (Courtesy of the Seil family.)

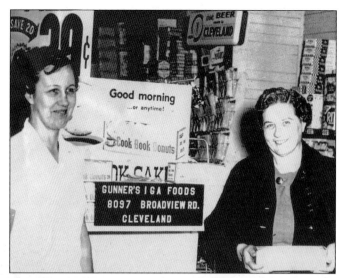

Clerk Rhonnie Dempsey and Bernice Gunner are photographed at Gunner's IGA market on the northeast corner of Broadview and Wallings Roads. The store was open from the start of Broadview Heights until the mid-1960s, when construction of a bank building and the relocation of the Shell station on the northwest corner led to all the buildings being torn down. The photograph on page 41 shows the street in 1958. (Courtesy of the Gunner family.)

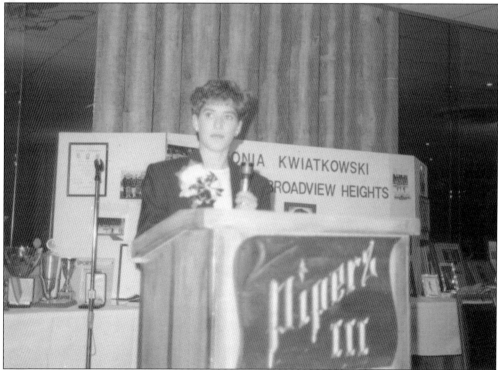

Tonia Kwiatkowski is pictured at her fundraiser sponsored by the City of Broadview Heights in 1993. Tonia was a three time US world team member and the silver medalist at the 1996 world championships. Kwiatkowski is one of a few world-class skaters to complete a college degree, which she did in communications and psychology at Baldwin-Wallace College in 1994. With daily practice for five to six hours, most skaters trying to reach the pinnacle of the sport do not bother to take the time to finish a college program, and some do not finish high school. With college behind her, Kwiatkowski made several strong finishes at the US Nationals and made the World Championship team in 1993, finishing third to be on the World team. She retired after the 1998 season and continues to be involved in the sport as a skater and coach. (Courtesy of CBH.)

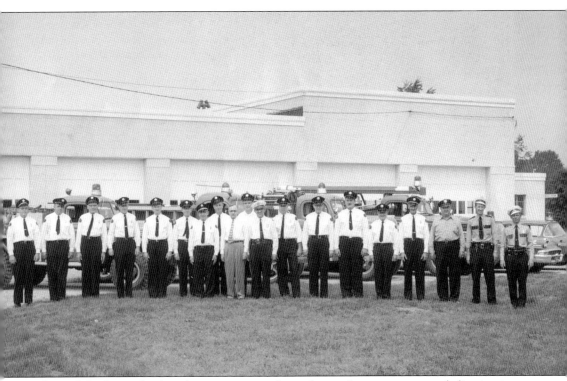

Members of the fire and police departments stand together at the service garage dedication in 1959. From left to right are firefighters Tom Born, Charles Koneval, Frank Vitt, Ray Bender, Bill Hardstock, and Floyd Tewksberry; fire chief Fred Perzy; Andy Smorji; Mayor Arthur Luempert; John Shannon; police chief Alex Kloka; Harvey Spotz; Len Burger; Donald A. Faulhaber; Rollie Kramer; Chan Humphrey; and police officers Riley Hecker, Walt Willard, and Nelson Temple. (Courtesy of the Koneval family.)

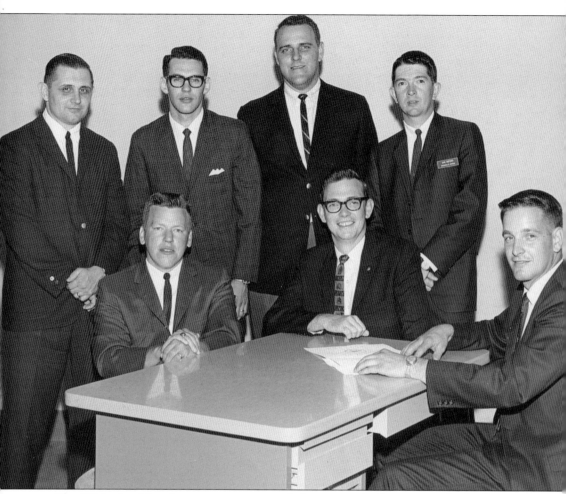

The US Junior Chamber, or more commonly known as the Jaycees, is a leadership training and civic organization for people between the ages of 18 and 41. Areas of emphasis are business development, management skills, individual training, community service, and international connections. The national organization was established on January 21, 1920, to provide opportunities for young men to develop personal and leadership skills through service to others. The local Brecksville–Broadview Heights chapter was approved on March 18, 1958, and an installation of officers was held at Ye Olde Stage House Restaurant. Fundraising projects through the years included a Jay Days Fair through the Fourth of July, an exhibition touch football game between the Jaycees and local television personalities Bob "Hoolihan" Wells and Charles "Big Chuck" Schodowski, the Purple Martin House Project, and Christmas tree sales. Pictured above are the 1966–1967 Jaycee officers. From left to right are (first row) Bob Amos, past president; Warren Tisdale, internal vice president, and Donald Faulhaber Jr., president; (second row) Burt Neal, treasurer; Frank DeWolf, external vice president; Don Bender, internal vice president; and Dan Oxford, secretary. (Courtesy of FF.)

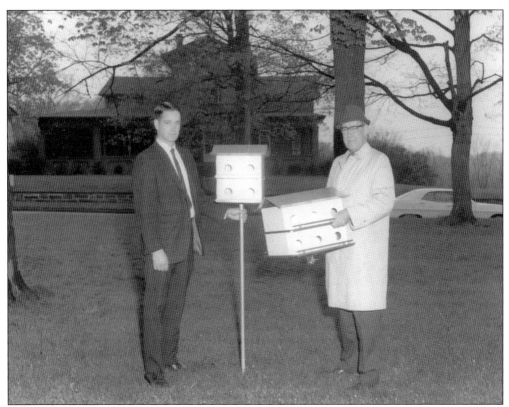

Brecksville–Broadview Heights Jaycee president Don Faulhaber Jr. (left) presents a purple martin birdhouse to Brecksville mayor William Gourley in 1967. The Jaycees started the Purple Martin House Project in an attempt to attract purple martins to the area again. Cold weather had kept purple martin families from settling in the community. The birds live in family "apartments" and have been known to eat their weight (equal to about 2,000 mosquitoes) in insects per day. Bird scouts are sent north in early spring to establish residence, so if the winter weather lasts into late April, the main flock of birds will not take up residence in the area. (Courtesy of FF.)

This news clipping highlights the Jaycee Wives who held an installation. These officers served during the 1966–1967 year. From left to right are (first row) Terrie Johnson, first vice president; Nancy Faulhaber, president; and Penny Quinn, second vice president; (second row) Betty Gleine, secretary; Carole Tisdale, treasurer; and Marilyn Amos, past president. (Courtesy of FF.)

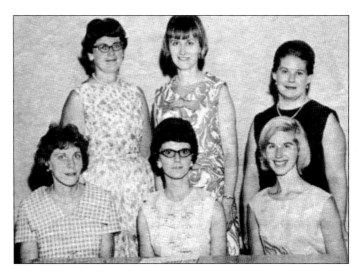

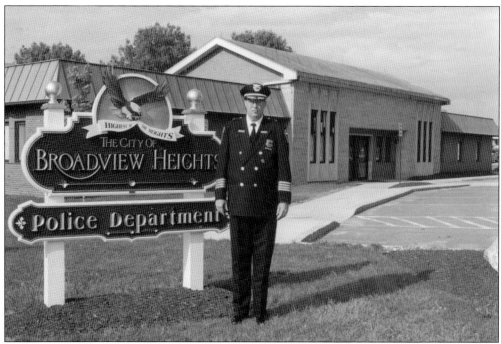

Police chief Robert Lipton stands in front of the new Broadview Heights Police Station. This station opened in early 2002 after extensive remodeling at the new city complex. (Courtesy of CBH.)

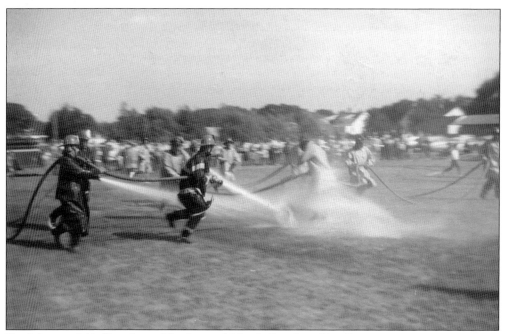

Firefighters of the Broadview Heights and North Royalton Fire Departments participate in a water fight during the annual Labor Day celebration. During these water bouts, it was fun to watch the barrel roll into the end zone, but every so often, the hose was aimed into the crowd for a refreshing spray of water. (Courtesy of FF.)

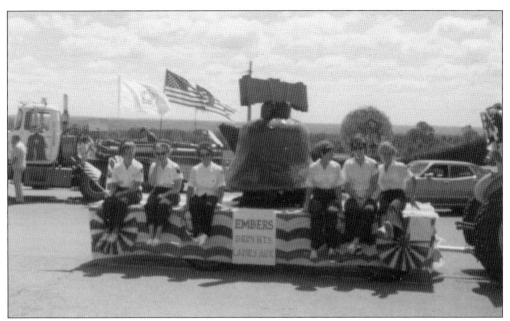

The Embers are a ladies auxiliary group of the Broadview Heights Fire Department. Here, they are participating on the Liberty Bell float for the bicentennial celebration in 1976. (Courtesy of FF.)

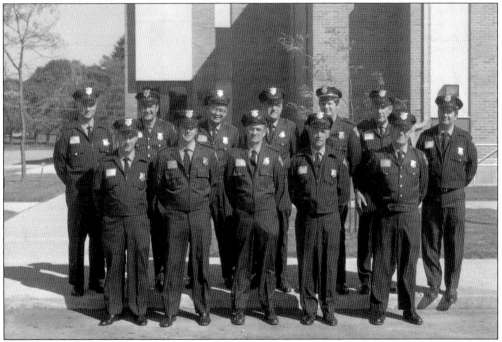

In 1974, auxiliary policemen assisted regular police officers with traffic patrol and other nonemergency situations. Unfortunately, a few members have not been identified. From left to right are (first row) Tony Apolzar, unidentified, Ed Gross, unidentified, and Joe Mixen; (second row) two unidentified policemen, Mike Gembala, Steve Drozdowski, Clay Tober, unidentified, and Gene Speziale. (Courtesy of the Tober family.)

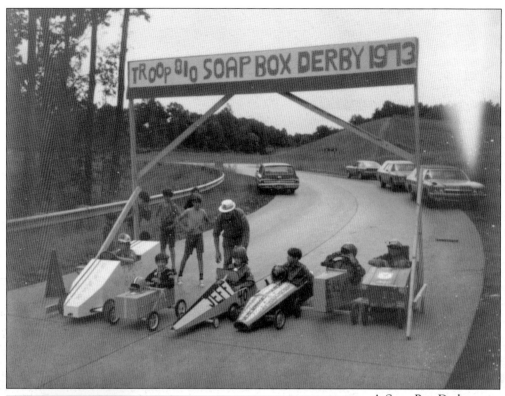

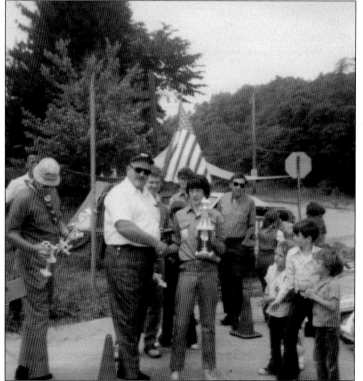

A Soap Box Derby contest was held on old Route 82 in 1973. The road was closed for Boy Scout Troop 810 to compete in homemade cars for the right to be called the fastest Boy Scout. Their troop leader was Clay Knotek. (Courtesy of the Bosky family.)

Mayor Donald A. Faulhaber presented the award for first place in this Soap Box Derby to winner Tom Bosky, who had built his car with instructions from the national Soap Box Derby committee in Akron, Ohio. (Courtesy of the Bosky family.)

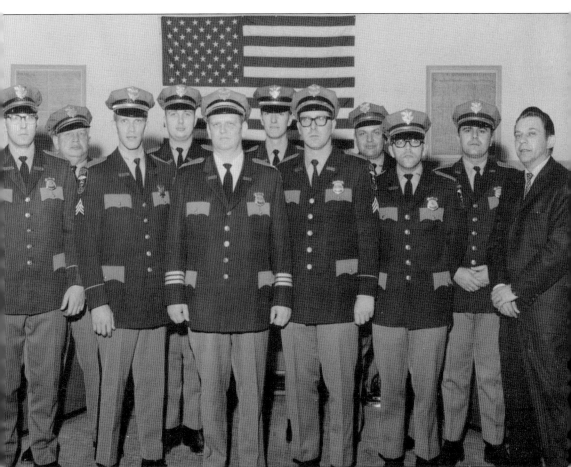

Members of the 1971 police department posed for this photograph. From left to right are unidentified, Paul Tober, Dave Kreiger, Fred Carmichael, Chief Ed O'Toole, Paul Loede, Bruno Tomasini, Dan Malafa, Chuck Knapper, Tom Lefkowski, and Mayor Frank Novy. (Courtesy of BHHS.)

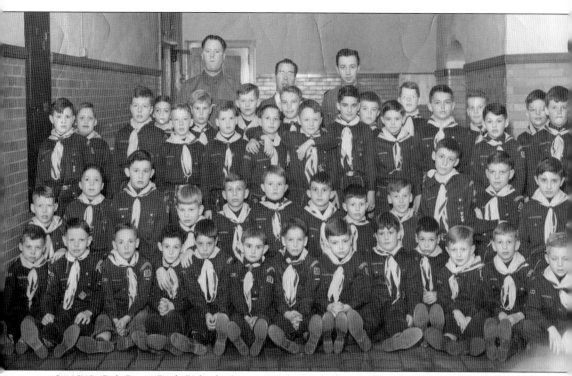

In 1948, Cub Scout Pack 59 had 45 scouts and 3 leaders. Scouting was new to Broadview Heights and to the children and their families. Almost 100 percent of the eligible first and second graders in school became members. The den meetings became a great way to meet and socialize. Many scouts and their parents become lifelong friends with other scout families. (Courtesy of FF.)

The Itschner sisters, from left to right, Rose Trapp, Elsie Hecker, Lydia Fuchs, and Clara Means, are shown together in 1958. They were very influential in organizing and helping to start Broadview Heights village. They attended the Avery Road schoolhouse and, after completing eighth grade, returned to teach until the school closed in 1915. (Courtesy of the Trapp family.)

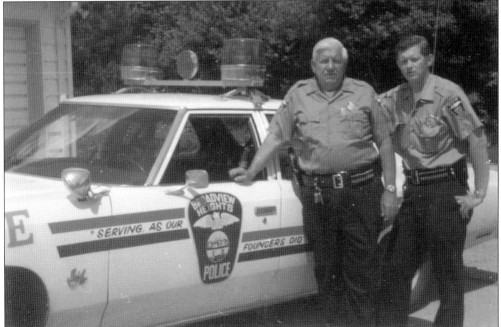

Father Paul and son Clay Tober are pictured with a police car marked with special decals to commemorate the bicentennial event in 1976. The Tobers were the second father-and-son duo to serve on the Broadview Heights Police Force. Mayor Arthur Luempert appointed Alex Kloka as chief in July 1954. While chief, Kloka had a number of fender benders and ultimately died of natural causes on September 1, 1966. Ironically, his son Brian lost control while chasing a reckless speeding car and died on August 28, 1967; he was the only Broadview Heights policeman to die while on duty. (Courtesy of the Tober family.)

Police chief Fred Carmichael and his squad are pictured keeping abreast of the latest developments in law enforcement after Broadview Heights hooked into the new LETN satellite television network. (Courtesy of BHHS.)

From left to right, patrolman Paul Loede, unidentified, Bruno Tomasini, and Chief David Kreiger march together in the 1980 Memorial Day parade to commemorate the holiday and the veterans who have served their country. All city departments, along with most organizations, participate in this tradition, which was started shortly after the end of World War II. (Courtesy of BHHS.)

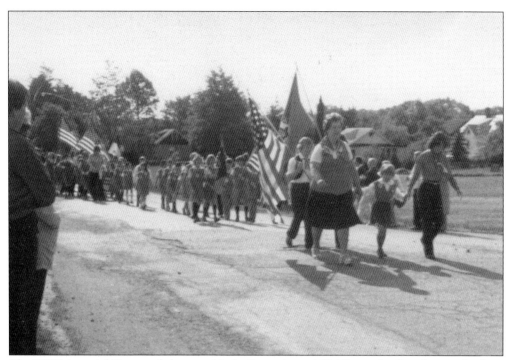

The 1980 Memorial Day parade began with the Brownies and Girl Scouts leading the march, along with other organizations and city officials. The flag raising, riffle volley, taps, and a short patriotic speech were all included in the program. After the ceremony, all participants and spectators were invited to the fire station for donuts, coffee, and soft drinks. (Courtesy of BHHS.)

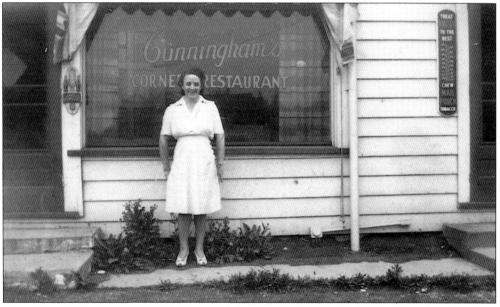

Kate Cunningham is pictured in front of the Cunningham Family Restaurant, located on Broadview Road directly across from Assumption Church. Families gathered not only from Broadview Heights, but also from surrounding communities to enjoy the food and entertainment in the 1950s. (Courtesy of BHHS.)

The nation's youngest DJ, Candy Lee, was a child radio and television personality in the 1950s. In 1985, Candy was inducted into the Broadcasters Hall of Fame. Her career began by winning a beauty contest at the age of three, then placing as runner-up in the Little Miss America contest at the age five. She screen-tested with Bob Hope for a part in the movie *Sorrowful Jones* and became cohost of *Uncle Jake's House* on WEWS-TV at age six. (Courtesy of Candy Lee.)

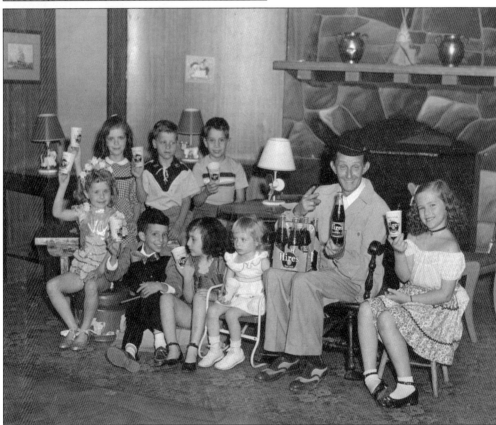

Candy, age eight, is shown with Gene Carroll and kids, advertising Hire's Root Beer. Candy cohosted with Gene five days a week for two years, then hosted *Candy's Kiddee Korral* on WDOK Radio. The show grew with Candy, and during its 10 years on the air, the program became the *Soda Set Show* and finally the *Candy Lee Show*. During this time, Candy also made regular appearances as a singer and dancer on the *Gene Carroll Show*, in addition to record hops and personal appearances. (Courtesy of Candy Lee.)

In 1959, Candy appeared on the popular television show *What's My Line?* with John Daley as host, and she stumped the panel, which included Bennett Cerf. (Courtesy of Candy Lee.)

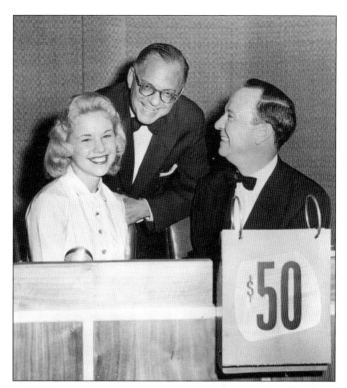

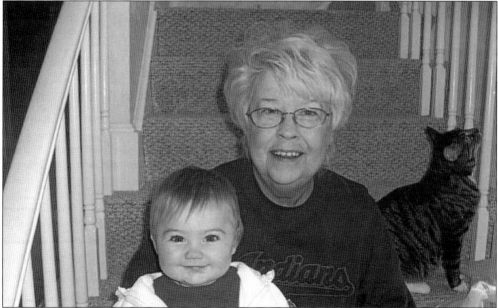

Candy and her granddaughter McKayla McGee, age two, were photographed together in 2007, along with Puddycat. While in Baldwin Wallace College, Candy hosted her own radio program and continued personal appearances to help raise money for many charities. She worked in Cleveland as office manager for Sen. Howard Metzenbaum and Sen. John Glenn for 18 years and is now retired. In 2015, she accepted the position of president of the Broadview Heights Historical Society. (Courtesy of Candy Lee.)

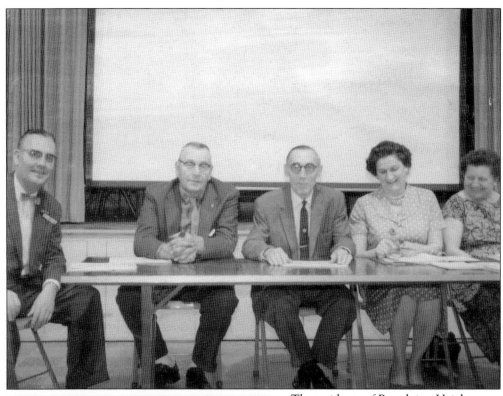

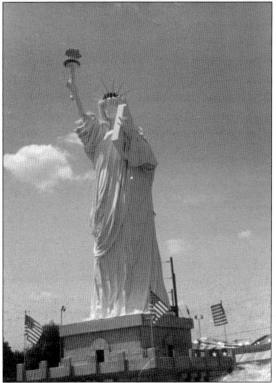

The residents of Broadview Heights were like most typical small towns where the elections were nonpartisan. The mayor and council were elected in general elections, and if a majority vote is not achieved, a runoff election was held between the top two vote getters. The candidate achieving the most votes was declared the winner and took office immediately following the election board's certification of the vote. One of the organizations in Broadview Heights was the Democratic Club. From left to right are members Cecil Mauk, Bob Svobada, Carl Trinkner, Elnore Gehring, and Fran Minich. (Courtesy of the Woelfl family.)

Broadview Heights residents loved parades and parties in general. In 1986, Candy Lee Korn was cochair of the Statue of Liberty reconstruction and 100-year anniversary celebration. A parade and picnic followed with games for the children. (Courtesy of CBH.)

Walt and Doris Turski constructed the Statue of Liberty from a store mannequin. The entire statue and its platform measured over eight feet tall. (Courtesy of CBH.)

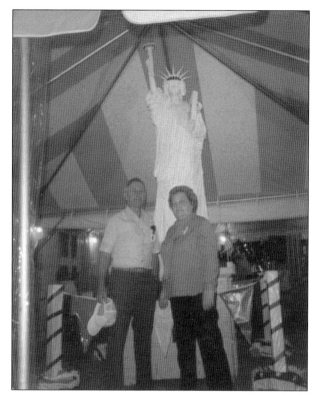

Penny Korn McGee appeared as Molly Pitcher in the Statue of Liberty Parade. (Courtesy of CBH.)

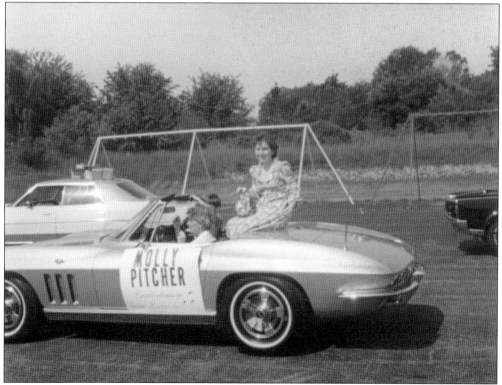

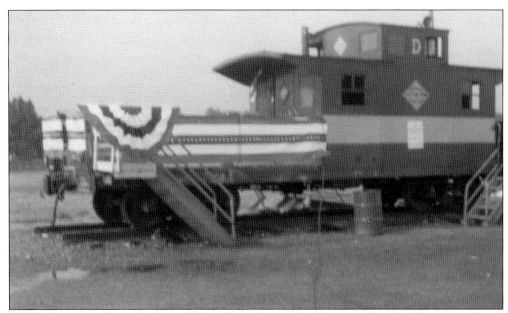

This caboose was donated in the 1970s to be used as a refreshment center for the memorial park activities. (Courtesy of CBH.)

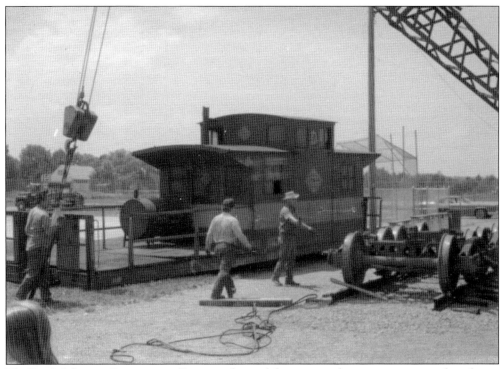

The Frank Salvatore Construction Company donated their time and manpower to move the caboose in four separate sections from the Cleveland flats area to the Broadview Heights recreational fields. The caboose lasted for over 30 years as a refreshment stand and podium for various functions. (Courtesy of CBH.)

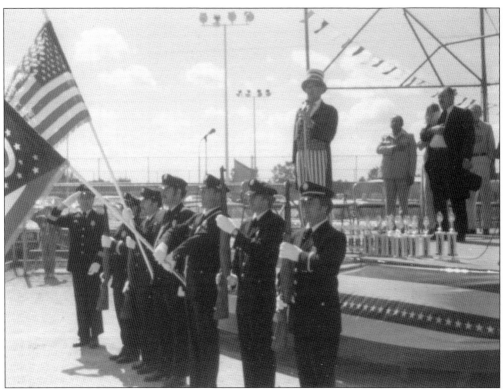

The 1976 bicentennial celebration in Broadview Heights featured a sanctioned parade with 97 units and over 1,400 participants. A sanctioned parade means points are given to each unit entered, and prizes are awarded by national organizations. Groups travel the country to participate. The platform of the caboose was the focal point for the awards presentations. Pictured above is the police color guard during the national anthem. (Courtesy of FF.)

From left to right, Mayor Donald A. Faulhaber (wearing a top hat), master of ceremony Andy Cornish (stars and stripes clothing), parade chairwoman, Nancy Faulhaber, and two unidentified persons are pictured with participants while spectators eagerly awaited the start of the awards ceremony. (Courtesy of FF.)

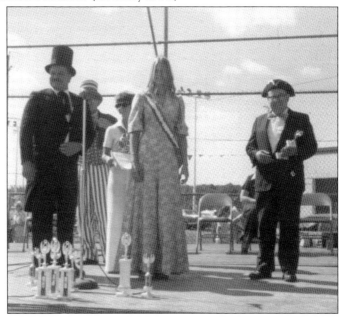

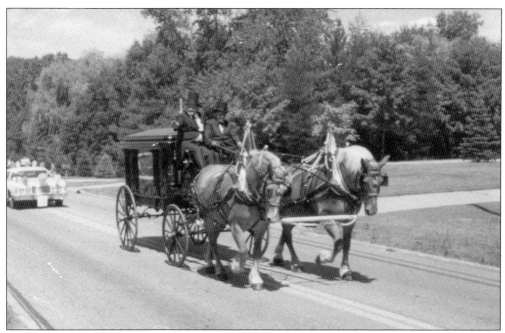

The two-hour parade featured 33 local organizations, US Navy Drum and Bugle Corps from Toledo, motorcycle and mounted units, Krazy Kops, youth baton groups, 12 bands, and numerous other featured groups. Shown above is Mayor Donald A. Faulhaber, who is also a funeral director, riding on a 100-year-old horse-drawn hearse. (Courtesy of FF.)

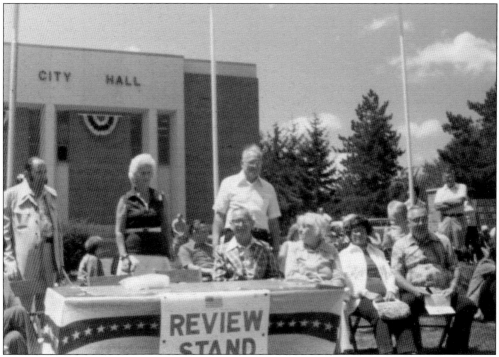

The reviewing stand in front of city hall held a panel of All-American Contest Association judges, along with the mayors and city officials of other communities. (Courtesy of FF.)

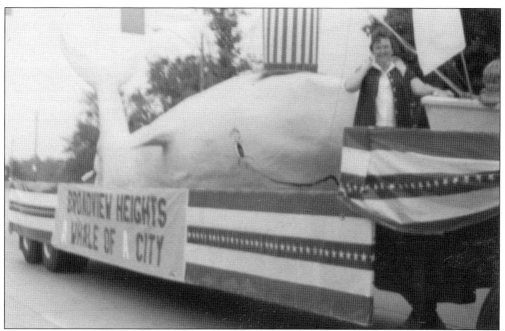

Wallings Road Elementary School was built in the late 1920s to accommodate the younger children in the Broadview Heights area. All other students went to the central school in the center of Brecksville. The school closed shortly after opening because there were not enough students. After World War II, the school reopened in 1947 for grades one through six. With the rapid community growth, the school was a vibrant part of Broadview Heights, but declining enrollment led to its permanent closure in the mid-1980s. The school's nickname, "the Whale," inspired the concept of a featured entry in the bicentennial parade, as seen with chairwoman Robinette "Bobbi" May on board the float. (Courtesy of FF.)

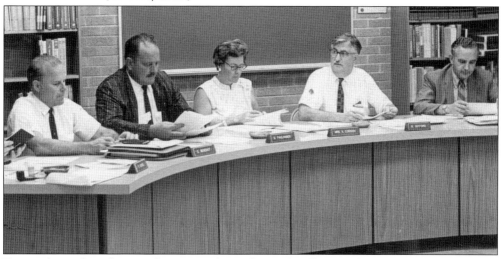

Five residents, elected every other year, make up the Brecksville–Broadview Heights School Board. The Brecksville School graduated its first student in 1884. The district has grown to include a high school, middle school, central school, and three elementary schools. Members of the 1968 school board are, from left to right, Claude Benedict, Donald A. Faulhaber, Tory Cornish, Roger Gifford, and Fred Nichols. (Courtesy of FF.)

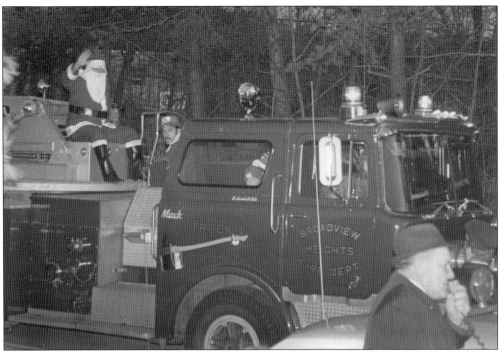

Under the direction of Mayor Donald A. Faulhaber, the first Christmas tree lighting ceremony was held on December 8, 1974, with Santa arriving on the fire truck. (Courtesy of FF.)

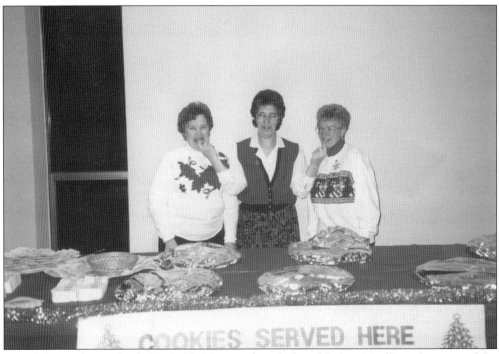

From left to right, cookie ladies Bobbi May, unidentified, and JoAnn Nejdl sneak a taste of the treats before the program begins. (Courtesy of FF.)

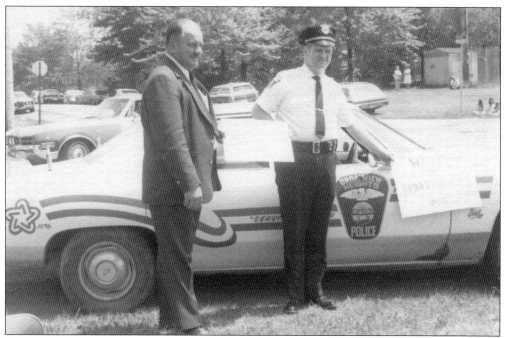

Mayor Donald A. Faulhaber and police chief Ed O'Toole are shown presenting new police cars with the bicentennial logo painted on the side of each vehicle to the residents of Broadview Heights. (Courtesy of FF.)

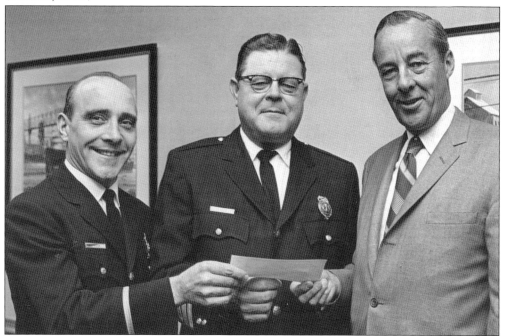

Broadview Heights fire marshal Leonard Masek (left) and fire chief Tom Born (center) present a check from members of the fire department to the president of Republic Steel Corporation (name unknown). Republic Steel Charities provided funds within the city of Cleveland to the less fortunate in the community. (Courtesy of BHHS.)

Resolution

CITY OF BROADVIEW HEIGHTS

RESOLUTION NO. 77 - 56

INTRODUCED BY: THE ENTIRE COUNCIL

A RESOLUTION COMMENDING THE BROADVIEW HEIGHTS
GOLDEN ANNIVERSARY COMMITTEE FOR THE SUCCESSFUL
PROMOTION OF THE CITY OF BROADVIEW HEIGHTS
GOLDEN ANNIVERSARY CELEBRATION HELD FROM
THURSDAY, JULY 28 THROUGH SUNDAY, JULY 31, 1977.

WHEREAS, the Broadview Heights Golden Anniversary Committee sponsored the City of Broadview Heights Golden Anniversary Celebration, and

WHEREAS, the Administration, this Council and the residents of the City of Broadview Heights did appreciate the efforts of the members of the Golden Anniversary Committee in promoting the City of Broadview Heights Golden Anniversary Celebration,

NOW, THEREFORE, BE IT RESOLVED BY THE COUNCIL OF THE CITY OF BROADVIEW HEIGHTS, COUNTY OF CUYAHOGA AND STATE OF OHIO:

SECTION 1: That on behalf of the Administration, this Council and the residents of the City of Broadview Heights, this Council hereby acclaims and commends the members of the Golden Anniversary Committee, to wit: Chairperson Bobbie May, Richard May, Sophie Klipfell, John Klipfell, Patricia Erhard, William Walker, Marie Bender, Paul Zakriski, Ken Marshall, Kathy Zamiska, Nancy Faulhaber, Jackie MacFarlane, Robert MacFarlane, Bee Dee Hein, Ruth Rickmers and Donald A. Faulhaber for their outstanding contributions in making the City of Broadview Heights Golden Anniversary Celebration a success and a memorable occasion.

SECTION 2: That the Clerk be and she is hereby directed to deliver a certified copy of this Resolution to each of the members of the Broadview Heights Golden Anniversary Committee.

DATE PASSED: *October 3, 1977* *Biagio A. Sidoti*
Biagio A. Sidoti, President of Council

DATE FILED
WITH THE MAYOR: *October 4, 1977* APPROVED: *Donald A. Faulhaber*
Donald A. Faulhaber, Mayor

ATTEST: *Virginia J. Klimek* DATE APPROVED: *October 4, 1977*
Virginia J. Klimek, Clerk of Council

A resolution dated October 3, 1977, commends the Broadview Heights Golden Anniversary Committee for the successful promotion of the 50-year anniversary of the founding of Broadview Heights. The celebration was held from July 28 through July 31, 1977. (Courtesy of FF.)

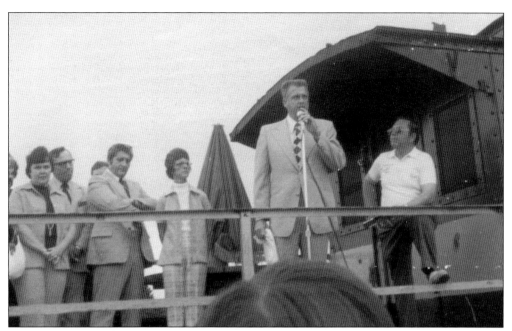

Congressman Ronald M. Mottl presents a proclamation from the US House of Representatives celebrating the 50th anniversary of the founding of Broadview Heights. (Courtesy of FF.)

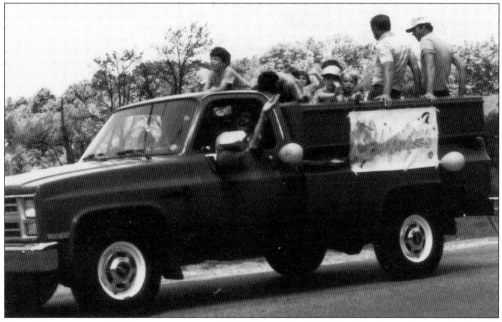

Over the years, parades became very popular in Broadview Heights. Without the parades for the bicentennial celebration, 100-year anniversary of the Statue of Liberty, and 50-year celebration, which only occur once in a lifetime, there was not enough action during the summer months. The recreation department started a parade with all the Little League teams to kick off the summer baseball program. Pickup trucks, trailers, and vans carried the kids on Broadview Road to the diamonds at the Memorial Park Fields, where the games were held and everyone had a great time. (Courtesy of the Ziebert family.)

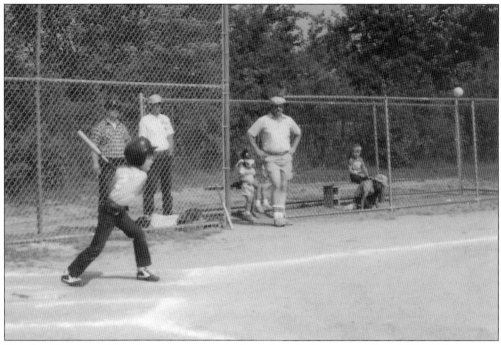

The familiar chant "Hey, batter, batter, swing" was heard all summer. Here, Mike Ziebert, takes his turn at bat in June 1985. (Courtesy of the Ziebert family.)

Broadview Heights Fun Days kept the action going when the games were over. (Courtesy of the Ziebert family.)

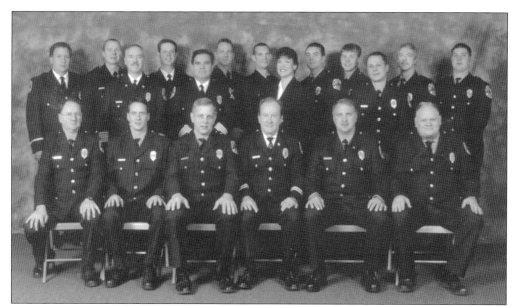

Members of the 2002 Broadview Heights Fire Department are pictured here. From left to right are (first row) Tim Dodd, Tom Lisy, Michael O'Toole, Capt. Dan Cloonan, Kris Vajda, and Bruce Ryan; (second row) Lt. Rick Neiden, Jeff Gembus, Chief Lee Ippolito, Lt. Duffy Hajek, assistant chief Joe Fleming, Bob Franco, Lt. Jay Gaiser, administrative assistant Pat Koss, Anthony Strazzo, Mike Franko Jr., Steve Morabito, Mike Franko Sr., and Dan Schreiber. (Courtesy of the Broadview Heights Fire Department.)

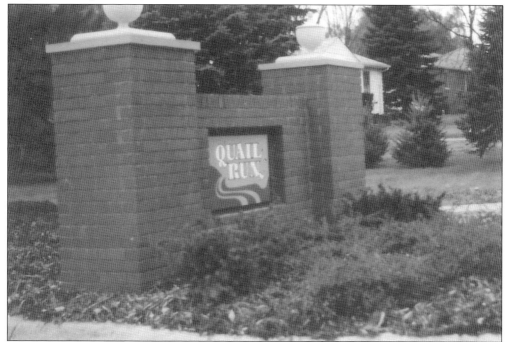

The Quail Run development broke ground in October 1986. Farmland was converted to home developments and has continued to increase the population of Broadview Heights. (Courtesy of the Ziebert family.)

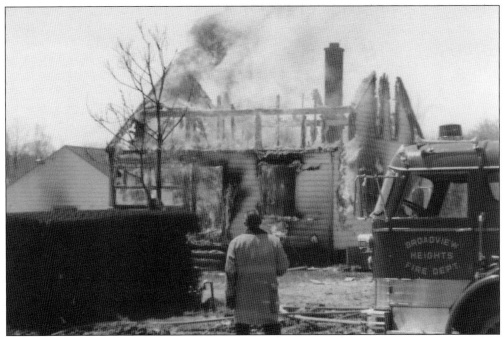

A controlled burn and practice session took place at this vacant house in front of the soon-to-be Quail Run Development. The opportunity to train new firefighters in a controlled structure fire teaches each recruit quickly and has a lasting image of how to extinguish a house fire. (Courtesy of the Ziebert family.)

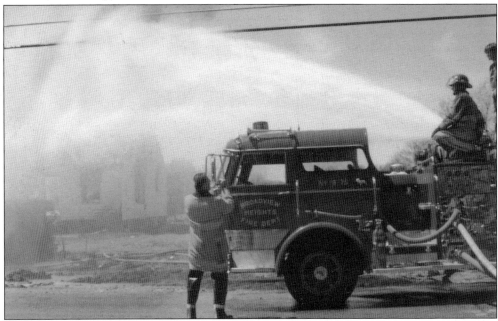

When the training session was over, the fire was extinguished, and a long practice day was complete. Since Broadview Heights is a rural farming community with slow residential growth and few building fires recorded over the years, the entire department benefits from this training experience. (Courtesy of the Ziebert family.)

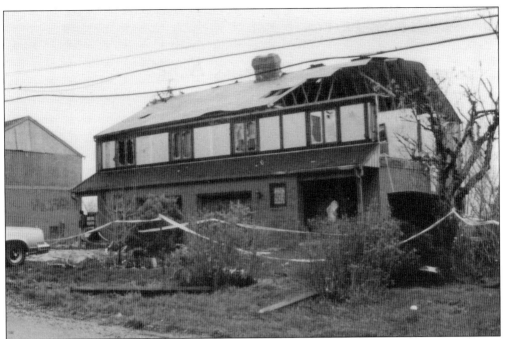

On May 2, 1983, a tornado touched down in Broadview Heights and the neighboring community of Brecksville, destroying 9 homes and causing damage to 22 others. The winds were estimated at 158–206 miles per hour and classed as an F-3 tornado, with a swath of 100 yards wide and 12 miles long. (Courtesy of the Ziebert family.)

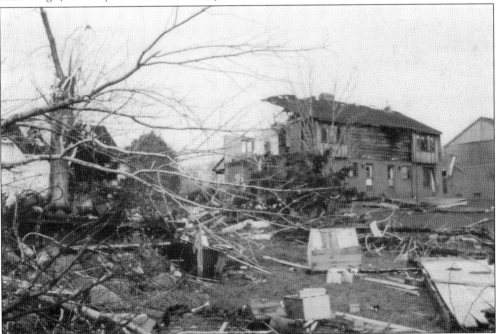

The 1983 tornado hit at 4:50 p.m. The fierce winds lifted cars and tipped tractor-trailers on Interstate 77. According to witnesses, there were "three seconds of noise, then it got quiet." The homes shown are on Mill Road, just south of Wallings Road. (Courtesy of the Ziebert family.)

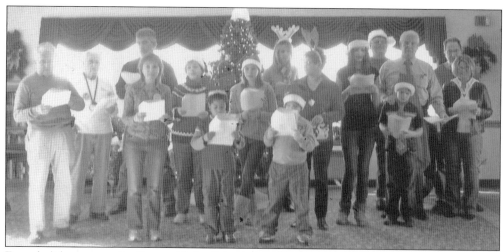

Every holiday season, the Rotary Club of North Royalton–Broadview Heights hosts a Christmas carol sing-along to entertain the residents of nursing homes and assisted-living facilities. Rotary is a service organization made up of members from the community dedicated to the improvement of each city and caring for those less fortunate. (Courtesy of Rich Cervenak.)

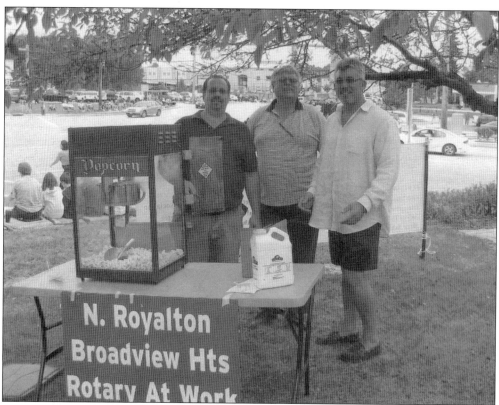

The Rotary Club of North Royalton–Broadview Heights is shown providing popcorn at the North Royalton Home Days Celebration. From left to right are members Jeff Ferrara, Rich Cervenak, and Tim Bosco. (Courtesy of the Rotary Club of North Royalton–Broadview Heights.)

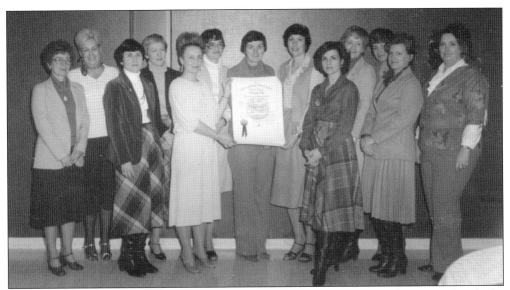

The Broadview Heights Lioness Club was chartered on January 16, 1980, then merged with the Lions Club in 1990 after a court ruling dissolved all gender member clubs. All service organizations nationwide became open to all persons regardless of sexual orientation. Charter members are, from left to right, (first row) Susan Zakriski (secretary), Barb Robinette (vice president), Bev Schreck (treasurer), Marge Savage, Toula Loizos, and Joyce Kruger (sunshine committee chair); (second row) Irene Koubek, Barb Bingham, Chris Marshall (historian), Dottie Ehlers (president), Chris Lee, Jean Laughlin, and Nancy Shreffler. (Courtesy of BHHS.)

Donations from the Lioness Club helped build a tot lot for the children to climb and play. The club's motto is expressed in an acronym of the Lions name: "L" for Liberty, "I" for Intelligence, "O" for Our, "N" for Nations, and "S" for Safety. (Courtesy of BHHS.)

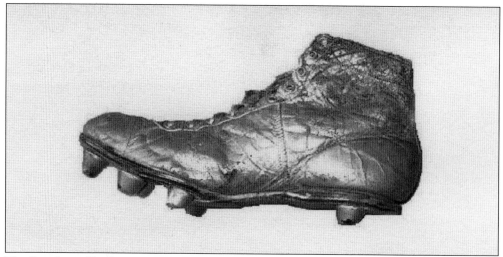

The Broadview Heights area was part of both Brecksville and North Royalton Townships for 116 years. Broadview Heights is still part of both Brecksville and North Royalton School Districts. The idea of establishing a symbol that recognizes the enthusiastic, respectful, honorable, and fun rivalry that existed between the two schools started in 1936. An old shoe painted a gold color became that symbol. Since Royalton lost the first game, they had to provide the shoe, which was worn by Royalton player John Wiseman. The presentation was made to Brecksville High School because they won the first game and their school colors are crimson and gold. Each year since, except for the four years when Royalton and Brecksville–Broadview Heights did not play each other, the shoe sits in the winner's showcase until the next year's game. The winning total now is Brecksville–Broadview Heights with 55 and North Royalton with 20. (Courtesy of the Brecksville Broadview Heights Alumni Association.)

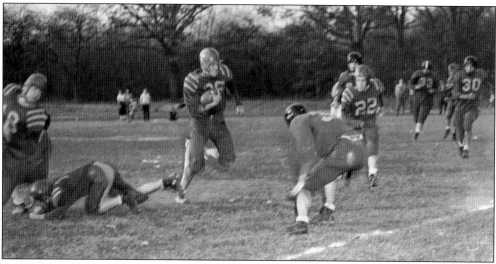

Football became a popular sport in the 1920s and 1930s. This game between North Royalton and Brecksville–Broadview Heights High Schools is from the late 1940s. The Brecksville team has the white stripes on their shoulders. Notice the leather helmets with no face masks and lack of lighted fields. (Courtesy of Walter Wisnieski.)

84

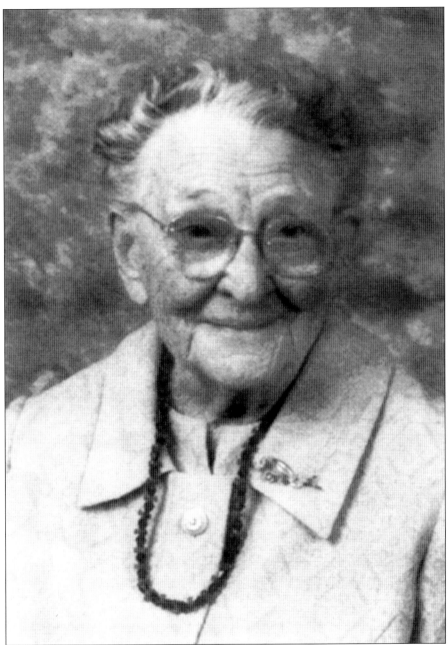

Catherine Kelleher was a Gold Star Mother and an all-star volunteer for former servicemen. Her son James, a tail gunner, was killed in 1944 when he was shot down on his ninth Army Air Forces flight over Germany. When she went to the Veterans Administration to file for his benefits, she looked so sad that the general suggested she try volunteering. When she retired at the age of 98 in 1987, she had been a volunteer at VA hospitals for 43 years, logging 34,271 hours helping ailing servicemen who were her "boys," and she, their "mom." She was Santa Claus at Christmas and wore bunny ears for Easter. She sometimes baked as many as 1,500 cookies a month for VA patients. She was honored by the VA several times and received the highest volunteer service award in 1985. (Courtesy of FF.)

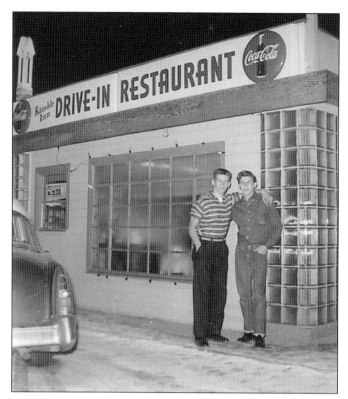

The Ramble Inn was built by two friends, Ron Breune (left) and Phil Kwiatkowski (right), in the early 1950s, and when opened, it was reported to be one of the first, if not the first, drive-in restaurant in the northern Ohio area. The Ramble Inn is still open, operating as a casual restaurant and bar. (Courtesy of BHHS.)

Shirley Aley Campbell has created a luminous career painting the invisible people, or as she says, "the ugly ones"—the ones who have had misery but who do not give up on life. According to Shirley, "I take people who are not beautiful and paint them in a way to make them beautiful—in a way they would like to see themselves." She is a professor emeritus at the Cleveland Institute of Art and the Cuyahoga Community College. She has paintings hanging in the Cleveland Museum of Art, the Butler Institute of American Art, the University of California, Los Angeles (UCLA), and other international collections. (Courtesy of FF.)

Ed Rubes was proud to serve in the Navy during World War II as a medical corpsman in Okinawa and North China. Rubes worked as an electrical estimator and construction project manager for 50 years. Upon retirement, he volunteered at his church and for the Broadview Heights Human Services Department. A proud veteran, Rubes attended all veteran functions and assisted those in need whenever he could. (Courtesy of the Rubes family.)

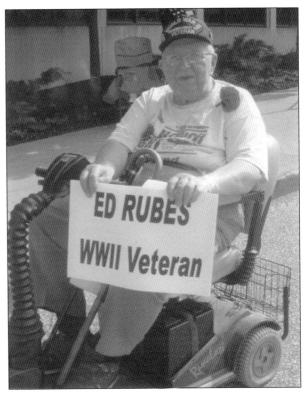

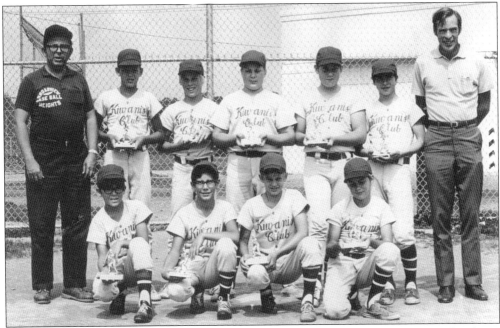

In 1972, Ed Rubes and Bob Smith coached the Babe Ruth Little League baseball team. The players are, from left to right, (first row) Edward Rubes, Bob Sykora, John Tyma, and Frank Moreno; (second row) manager Ed Rubes, Jeff Kosthler, Todd Smith, Mark Vasjkop, Angelo Bonsutto, Don Balint, and coach Bob Smith. (Courtesy of the Rubes family.)

The events of September 11, 2001, affected everybody, not only within the United States, but also internationally and locally. Brecksville, neighbor community to Broadview Heights, lost one of its residents on that fateful day. William Moskal lost his life while attending a meeting at the World Trade Center. He was a husband and father of two children and leaves a legacy of involvement in youth sports and an appreciation for the arts. (Courtesy of the Brecksville–Broadview Heights School Foundation.)

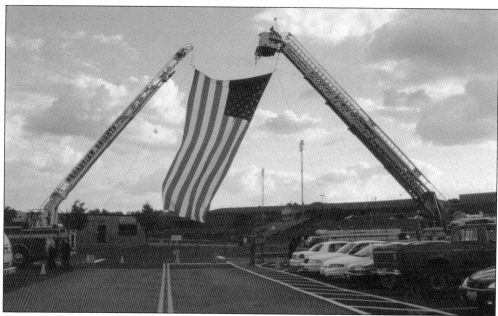

The huge American flag held aloft by two aerial ladder trucks formed an arch to all who entered the school athletic field for William Moskal's memorial service. A memorial scholarship fund was established in his name. The earnings from this fund will forever provide a scholarship to graduating seniors "who demonstrate a driven effort regardless of his/her individual talent." (Courtesy of the Brecksville–Broadview Heights School Foundation.)

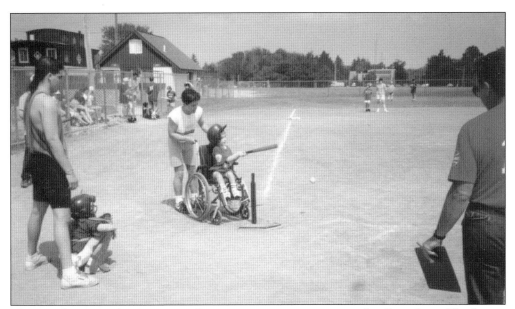

The Broadview Heights Recreation Department organizes activities for all residents. This league allowed the less fortunate of all ages to participate and become a team with their more athletic friends and neighbors whether they had two legs or two wheels. (Courtesy of CBH.)

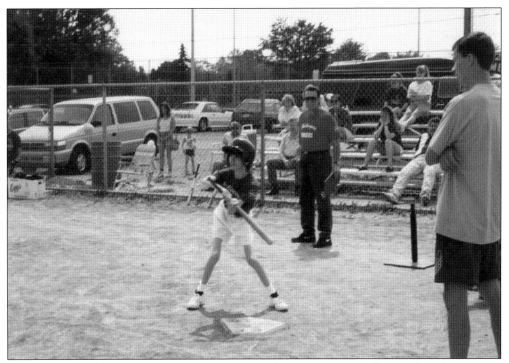

All children are able to participate in the recreational programs provided by the City of Broadview Heights. Learning to swing a bat and make contact with a ball, whether pitched or set on a tee, gives everyone an uplifting experience and much more confidence to try more adventurous activities. (Courtesy of CBH.)

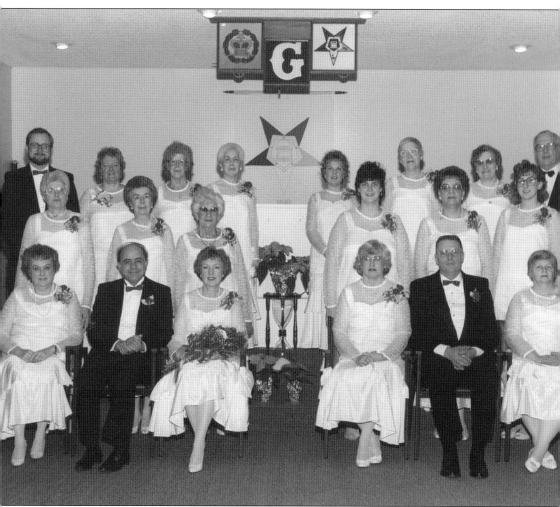

Eastern Star Lodge held their installation at the Brook Ridge Temple in December 1989. Members are, from left to right, (first row) Joan Quade, treasurer; George Chrisopulos, worthy patron; Vivian Chrisopulos, worthy matron; Janet James, associate matron; Hank James, associate patron; and Anne Loesch, secretary; (second row) Belva Smith, conductress; Dora Furry, Ruth; Flo Fennell, Esther; Dana Jones, mother; Barb Fair, electa; and Amy James, associate conductress; (third row) David James, marshal; Marilyn Kolp, soloist and protem; Martha Jesser, hostess; Phyllis Phillips, warder; Kathy Wessler, sentinel; Joan Obert, chaplain; Pat Townsend, organist; and Wilbur Smith, host. (Courtesy of the Chrisopulos family.)

Four

CHURCHES

Religion was a large part of the early settlers' background and heritage. Church services were held in homes and in barns, which were large enough to accommodate a group until funds became available to build a house of worship. Sharing services with poultry or livestock was not always an ideal situation, which resulted in either irritation or levity depending on where one sat. In the beginning, preachers were the early circuit riders who catered to Baptists, Disciples, and Episcopalians alike. In 1814, the first Methodist Church was formed in Brecksville Center, followed by the Congregational Church in 1816. In 1829, North Royalton Center was the location for the founding of the Disciples of Christ Church, now known as the Christian Church. The original settlers were overwhelmingly Puritan and Protestant. A few Catholic families settled in the area, and in 1857, Amadeus Rappe, the first bishop of the 10-year-old Diocese of Cleveland, organized the Assumption of the Blessed Virgin Mary Parish for the area that is now Broadview Heights. Through the years, other denominations and churches have been built to add to the diversity of the religious life in Broadview Heights.

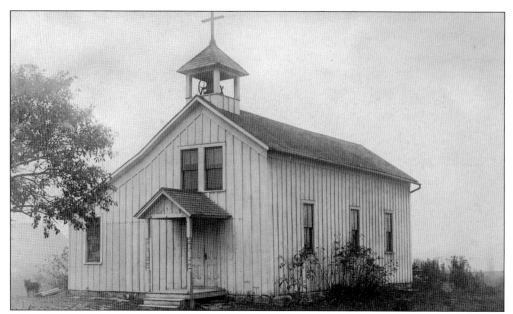

In 1904, Vaclav Behal gave an acre of farmland to the Diocese of Cleveland where a remodeled house would serve as the Assumption Church from 1905 to 1930. Priests from the St. Stanislaus Retreat House in Parma served the parish of 30 families until the first resident pastor, Fr. Michael F. Shannon, was appointed in 1913. (Courtesy of the Behal family.)

Note the simplicity of the church's interior. The operation of the church was also simple, as seen by the financial report for the year-end of December 31, 1907. Total cash receipts were $261.99 (including $50.48 from the Sunday collections and $61.33 from the mission picnic). Expenses amounted to $165.02 (including $20 for a horse and buggy and $15 for a Christmas crib). (Courtesy of the Behal family.)

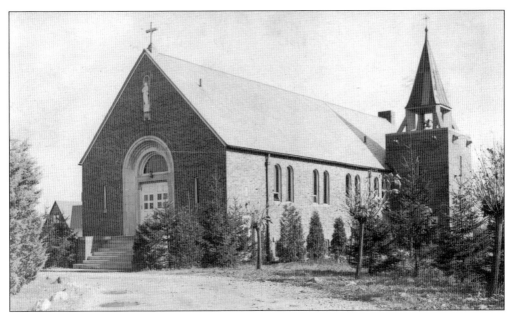

The growth of Broadview Heights also brought growth in church membership, and in 1929, the present land was purchased and a stone-trimmed brick building was constructed in the Romanesque style to seat 325 people. The dedication was held on August 24, 1930. This church remained in use until 1969. (Courtesy of Assumption Parish.)

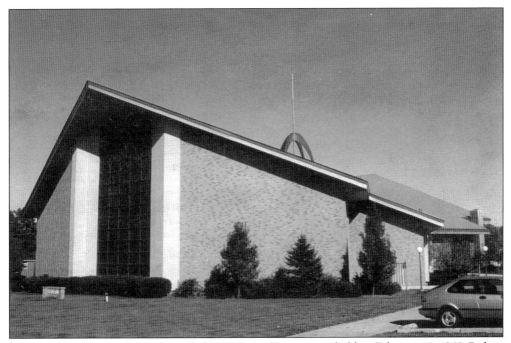

A ground-breaking ceremony, attended by 300 parishioners, was held on February 11, 1968. Bishop Clarence Issenmann dedicated the new structure with seating for 1,100 and a 44-foot-high stained-glass depiction of Mary's Assumption into heaven on August 17, 1969. (Courtesy of BHHS.)

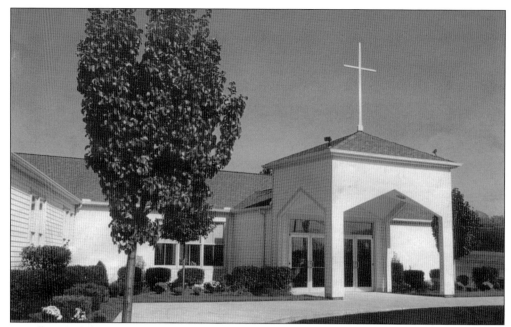

Broadview Heights Baptist Church was forced out of their home in Cleveland when the property was taken by eminent domain to make way for the Route 176 Jennings Freeway. The Broadview Heights location was dedicated and officially opened on November 9, 1996, the morning following a big snowstorm. Church services went well, but there was no electricity for Sunday school. (Courtesy of BHHS.)

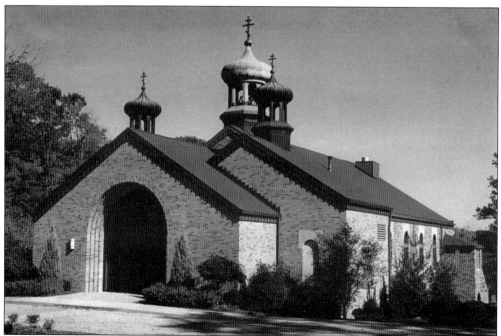

In 1971, the St. Michael's Russian Orthodox Church congregation approved the purchase of an 18-acre parcel of land on Mill Road at a cost of $38,000. The church opened on September 18, 1977. (Courtesy of BHHS.)

On Mother's Day 1957, a small congregation of 13 adults and 4 children interested in forming a Lutheran Church in Broadview Heights held their first worship service at the home of Wesley Brunswick. The Reverend R.W. Willmann, pastor of Parma Lutheran Church, conducted the service. Triune Evangelical Lutheran Church was chosen as the name for the new church, and at that time, it was the only Triune Lutheran Church in the nation. Seven acres of land was purchased on West Mill Road, with the building dedicated on December 20, 1959. The groundbreaking ceremony for a large addition to accommodate increased membership took place on April 16, 1970. (Courtesy of BHHS.)

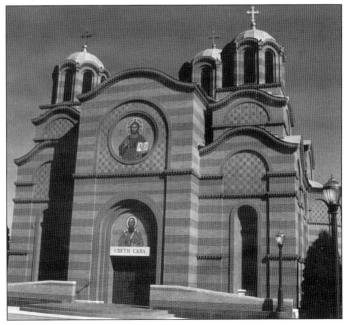

This is the St. Sava Serbian Orthodox Church. Families of Serbian heritage settled on the east side of Cleveland in the early 1900s. Church services were held at the Serbian Church on East Thirty-Second Street until 1963, when a new cathedral was built in Parma. After World War II, expatriates, unwilling or unable to live under a communist regime, settled in the area, and the new Serbian Eastern Orthodox Church on Wallings Road was dedicated in 1982. (Courtesy of BHHS.)

The Friends Church began in England more than 300 years ago under the leadership of George Fox. Those early Friends made great contributions to the spiritual and social needs of their country, taking the lead in securing prison reform, religious liberty, Christian education, and care for the suffering. Before long, the Friends (also called Quakers) began coming to the New World. In 1681, William Penn, a prominent English Quaker, founded the colony of Pennsylvania. The Broadview Heights Friends Church was established in 1947 by Quakers in the area who were concerned that Broadview Heights had no Protestant church presence. Known as "a small church with a big heart," the Broadview Heights Friends still places a high priority on its earliest focus of ministering to individuals. (Courtesy of BHHS.)

The Broadview Heights Kingdom Hall of Jehovah's Witnesses is a house of worship with members believing baptism by total immersion is a symbol of dedicating one's life to God. No collections are taken up during services at Kingdom Halls. Boxes are placed near the door so people can give as they wish. The Jehovah's Witnesses of Broadview Heights have been a mainstay in the area's religious community for a number of years. (Courtesy of BHHS.)

Five

GOVERNMENT AND BUSINESS

With the formation of Broadview Heights' governmental body on January 27, 1927, the village was ready to develop businesses, recreation, and residential areas for intelligent, designed growth. The fledgling automobile industry saw the arrival of the following service stations: Frank Masek at Broadview and Royalwood Roads, Broadview Heights Garage (featuring Willys, Knight, and Whippet cars), Cunningham at Broadview and Royalton Roads, Frank Zima Great Western Oil and Gas at Walling and Mill Roads, and John Vagner Shell at Broadview and Walling Roads. Insurance was available through Fred Clogg and C.G. Wilmont and Floyd Burton's General Store at Walling and Broadview Roads. Business growth was slow during the Depression years and World War II. After the war, in the late 1940s and early 1950s, residential growth increased, with businesses following to support the new population. Recreation was not forgotten either. Citizen donations and the formation of a Little League led to the purchase of three acres behind the village hall. Today, the city of Broadview Heights provides recreational areas not only for Little League but also for flag and tackle football, soccer, tennis, swimming, and a whole range of activities for young and old to play and enjoy as part of a healthy lifestyle.

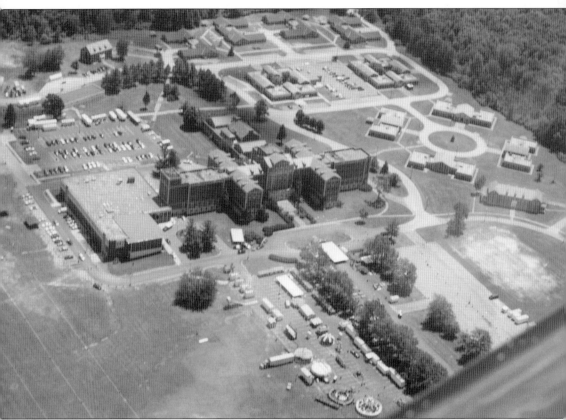

Looking east, this 2001 aerial view of the Broadview Heights City Complex shows all the buildings of the original Broadview Heights Veterans Hospital. The complex is now known as Broadview Center. The hospital closed in 1965, and the Veterans Administration transferred, for $1, the entire complex to the Ohio Department of Mental Hygiene. Newer buildings were added in 1972: the Thorn building attached to the left side of the main hospital building, the group of school buildings in the circular shape to the right, and some service buildings toward the top. Today, the only building left from the original hospital complex, built in 1939, is the attendants' building, home of the Broadview Heights Historical Society, seen at the top left of the picture. The City of Broadview Heights purchased the entire 68-acre parcel and all its buildings in 1996 for $750,000. Unfortunately, the main hospital building and most of the other structures had to be torn down. By removing the older, outdated buildings, areas were opened up for a new lighted football field, playground, and water park, along with a new entrance and other recreational amenities. (Courtesy of BHHS.)

The Broadview Heights
Broad VIEW Point

Broadview Hts., Ohio

AUGUST AND SEPTEMBER 1950

VILLAGE PARK

Broadview Heights Village Park Committee is purchasing approximately three acres of land adjoining the village hall property, with a frontage on Royalwood Road (see map on page 2).

As you will recall, this committee was organized four years ago to locate a tract of land for a park as a living memorial to our youth who served (and are serving) in the armed forces of our country. Of all the sites considered, this parcel of land proves to be the best suited from the standpoint of location, accessability, and suitability for the many activities it will make possible.

Purchase of this land, and the two buildings thereon, is being made from Mr. and Mrs. F. J. Clebisch of Royalwood Road.

THIS WILL BE YOUR PARK, and the property purchased will provide:--
 A LIVING MEMORIAL for all Service Men and Women of the Village,
 PICNIC SIGHT & PLAYGROUND with a base ball diamond,
 NEW ROAD TO BY-PASS DANGEROUS CORNER at Royalwood & Broadview,
 AMPLE SPACE FOR FESTIVALS & HOMECOMINGS with unlimited parking
 facilities for those attending village functions,
 COMMUNITY HOUSE and VILLAGE GARAGE can, at very nominal cost,
 be converted from the present buildings on the property.
 LAST but not LEAST - a project for all as individuals or org-
 anizations to develop and enjoy.

The Village Park Committee consists of the Mayor, two members of the Village Council, and two members from each of the following Village organizations: Blue Star Mothers, Chamber of Commerce, Dogwood Garden Club, and the Fire Department. Scout organizations are represented through these, their sponsors.

Election of officers was held August 16th as follows: President, Robert Yarian; V. Pres., William Horton; Secretary, Mrs. Lyle Bliss; Treasurer, Mrs. James Midgely. A BOARD of TRUSTEES was appointed to represent the Park Committee in negotiating for the purchase of this land, they are Robert Yarian, William Horton and Walter Davis.

(continued on page 2)

In August 1950, Broadview Heights residents proposed a village park consisting of three acres of land adjacent to the town hall property. This park is a living memorial for all the men and women who have served or are now serving in the US Armed Forces. (Courtesy of BHHS.)

MAP OF PRESENT VILLAGE PROPERTY & PROPOSED PARK PROPERTY

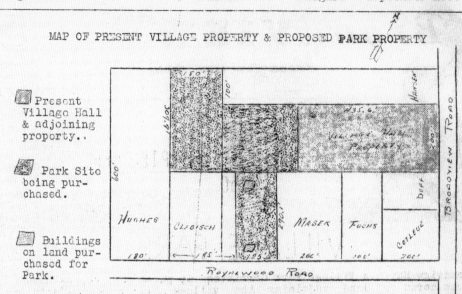

■ Present Village Hall & adjoining property..

▨ Park Site being purchased.

▢ Buildings on land purchased for Park.

NOW -- ABOUT THE COST. The purchase price of the Park land and buildings is $3,000.00. The Park Committee is purchasing the land with the Village of Broadview Heights as grantee so the title will be in the name of the Village as a continuation of present village property. There is $706.07 in the Park Committee treasury. The Chamber of Commerce voted, several years ago, to contribute a sizable amount. Because of the building which can be converted into a Street Department Garage, the Council voted to help with the purchasing of the property. The balance will be raised by popular sugscription.

YOUR HELP IS NEEDED. Here is your chance to help on this worth while project. If each family contributes, we can underwrite the purchase of the land and be able to develop it into something which all can enjoy and take pride. -- In making contributions to the Park Fund by check, make your check payable to "Broadview Hts. Park Committee" and mail or deliver it to any member of the committee or to 8308 Avery Rd. A self-addressed envelope is attached to this issue of the Broad View Point for your convenience. Names of contributors will be published in our next issue (unless otherwise requested by the individuals). We are counting on 100% cooperation from residents of Broadview Heights.

DO IT NOW -- This money must be raised within the next three weeks. This transaction goes into escrow on October first, at which time the $3,000 will have to be deposited. Deadline for this Fund Drive will be September 25th. By mailing your contribution promptly you will save the time and effort of a solicitor calling upon you personally, and enable the committee to have the finances in order by the end of the month.

Let's get behind this and make it a success.

-- Your Park Committee

This map shows the location of the park, complete with picnic grounds, baseball diamonds, and ample space for festivals and homecomings. It is a place for all, whether individuals or organizations, to develop and enjoy. Today, the property has expanded to include basketball courts and soccer fields, along with other recreational fields to accommodate the interests of everyone. (Courtesy of BHHS.)

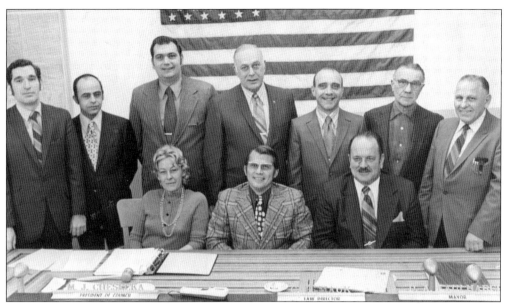

The first council meeting was held on January 17, 1972. The election of November 1971 saw the Faulhaber slate for mayor and eight councilmen to lead "A New Era in Broadview Heights." The city was close to default, services had been curtailed, roads were not being repaired, and police and fire personnel were at all time lows. This election and the business team approach helped restore Broadview Height's credit rating and the residents' faith in city government. From left to right are (first row) unidentified, council president Michael Cheselka, and Mayor Donald A. Faulhaber; (second row) council members Ernest Bergkessel, George Chrisopulos, William Bittle, John Klipfell, Leonard Masek, Joseph Mixan, and Douglas DeCarlo. (Courtesy of BHHS.)

The newly remodeled city hall was dedicated on November 4, 1973, following an extensive makeover inside and out to accommodate additional personnel and equipment. (Courtesy of FF.)

Domenic Del Corpo, a longtime business owner, sold his three-acre garden center property to the City of Broadview Heights in July 2014 so that green space would always be at the center crossroads of the city. (Courtesy of the Del Corpo family.)

Each and every year, Domenic Del Corpo would put out a wonderful display of flowers in the spring and summer, pumpkins at Halloween and Thanksgiving, and Christmas Trees of all shapes and sizes during the holiday season. At other times of the year, he had a variety of colorful displays to attract customers to his store. Here, Domenic and his granddaughter Kailee Mayher and the black cat are prepared for Halloween. (Courtesy of the Del Corpo family.)

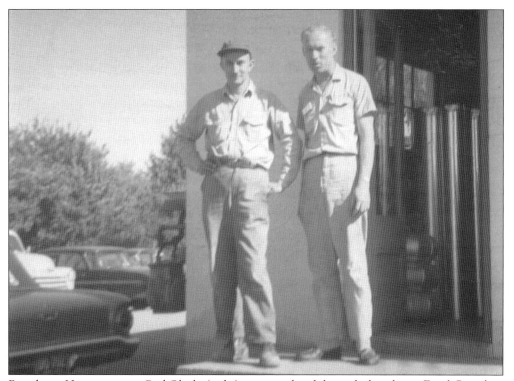

Broadview Heating owner Carl Olecki (right) is pictured with his right-hand man Frank Burtcher. Originally started by Stan Dostal, Tom Born, and George Payraczak in 1946, Broadview Heating is the longest-serving business in Broadview Heights. In 1960, Carl bought the business, which still continues today with the Olecki family. (Courtesy of the Olecki family.)

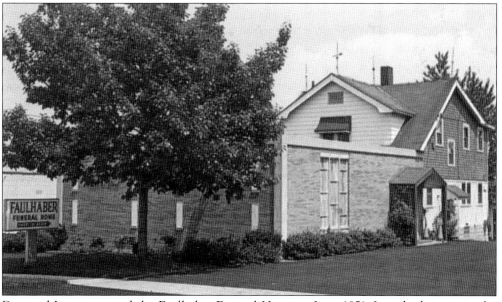

Don and Lenore started the Faulhaber Funeral Home in June 1951. It is the longest single-family-owned business in Broadview Heights, providing traditional services for families in need. (Courtesy of FF.)

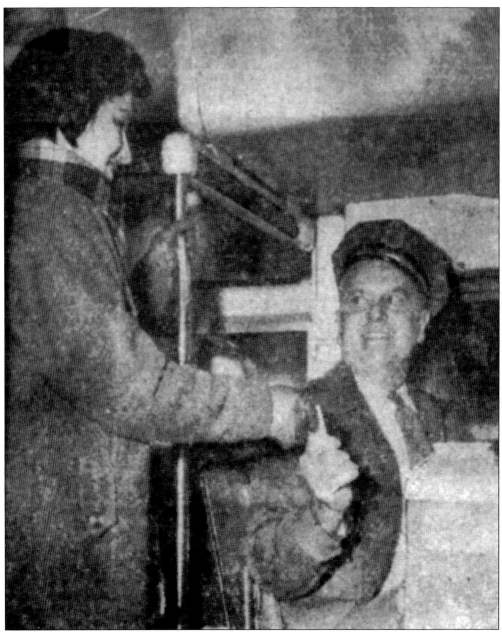

Broadview Bus Line was started in the 1940s through the efforts of Mayor Arthur Luempert, who negotiated with Harry Loder, owner of North Royalton School Bus Line. A joint effort between the communities of North Royalton, Broadview Heights, and Seven Hills franchised Loder to operate on Broadview Road to Cleveland between his school pickups. The business flourished, and in 1957, the Cleveland Transit System (CTS) made an attempt to put the Broadview Bus Line out of business by lowering fares by a nickel and offering more travel times. Eventually, CTS bought out the Broadview Road Route from the Loder family. Pictured here are rider Mrs. Donald Kuchar and bus driver Emil Lingler, also mayor of the city of Seven Hills. (Courtesy of BHHS.)

Aaron Costic is a certified master ice carver. Elegant Ice Creations is a dream come true for Aaron, who picked up a chainsaw and sculpted his first block of ice 25 years ago. Ice has been in his veins ever since. The company he built has grown into an 8,000-square-foot studio in Broadview Heights. He is a world champion with seven first-place finishes, six second-place finishes, and three third-place finishes. He has competed in three Winter Olympics, finishing with a gold medal at the 2006 games in Torino, Italy. (Courtesy of Aaron Costic.)

Aaron Costic crafted this ice sculpture titled "Spring," which is just one example of his ability to create delicate images from large blocks of ice. People return to reorder his centerpieces for weddings and corporate events. (Courtesy of Aaron Costic.)

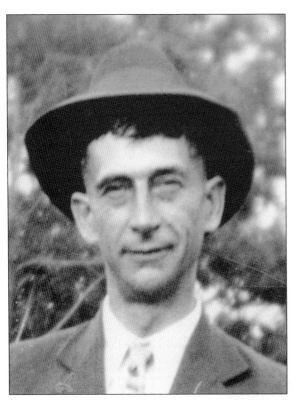

Floyd Harris served as mayor from January 1927 to May 1930. (Courtesy of CBH.)

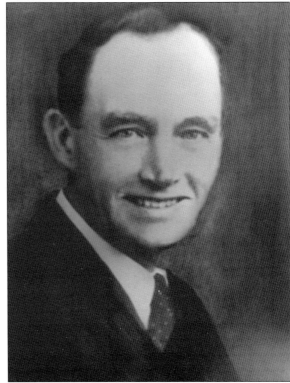

John P. Cunningham served as mayor from May 1930 to January 1, 1934. Mayoral elections are held every two odd-number years, with the winning candidate taking office in January of the even-number years. (Courtesy of CBH.)

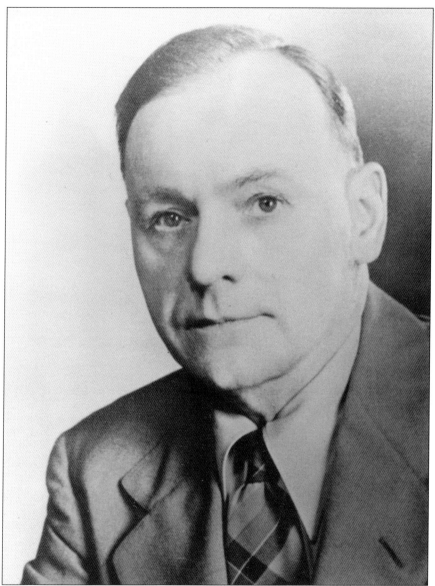

Arthur J. Luempert served as mayor from January 1, 1934, to January 1, 1954, and from January 1, 1956, to January 1, 1962. Mayor Luempert is the longest-serving mayor, at 26 years. His years as mayor, especially the first 20, saw the most development within the new village. He persuaded the federal government to finance installation of a water line extension from just north of the village line to Oakes Road, East Ohio Gas to run their lines into Broadview Heights, and Cuyahoga County to install a bridge over Chippewa Creek on Avery Road. In the early days of Broadview Heights, the mayor wore many hats: judge, police chief, fire chief, service director, and justice of the peace. As the community grew, all these responsibilities were delegated to department heads to run the everyday activities, leaving the mayor to lead the growth of the village. When the village of Broadview Heights was formed, Arthur Luempert was the justice of the peace who administered the oath of office to the newly elected mayor and council. He then served as treasurer for two years before being elected as mayor. His day job was superintendent of the Lee Road Electric Company. (Courtesy of CBH.)

Gilbert Manke served as mayor from January 1, 1954, to March 1954. Manke became sick within a few weeks of taking office and had to resign, allowing the president of the council, Leo T. Bender, to assume the position of mayor. (Courtesy of CBH.)

Leo T. Bender served as mayor from March 1954 to January 1, 1956, and from June 1971 to January 1, 1972. Leo T. Bender is the father of Leo H. Bender, the only father and son to hold office as mayor of Broadview Heights. Bender was council president twice, taking over as mayor once when Gilbert Manke resigned and for the second time when Frank Novy resigned from office. (Courtesy of CBH.)

Raymon Fetzek was mayor from January 1, 1962, to January 1, 1968. He defeated longtime mayor Arthur Luempert with a blitz campaign primarily directed to the new residents of the community. With a population over 5,000, Broadview Heights had just become a city in 1961, so those new to the area were persuaded to vote for Fetzek. (Courtesy of CBH.)

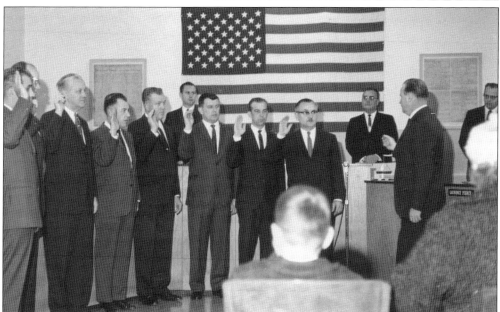

On January 1, 1964, Mayor Raymon Fetzek and city officials took the oath of office for the 1964–1966 term. From left to right are Larry Pierce, Jack Corrigan, Franklin Detwiler, Jim Fahey, Frank Gehring, Mayor Raymon Fetzek, Ted Growth, Ken Solecki, Leo T. Bender, Cecil Mauk, Cuyahoga County commissioner Hugh Corrigan (administering the oath of office), and Bob Yarian. (Courtesy of the Woelfl family.)

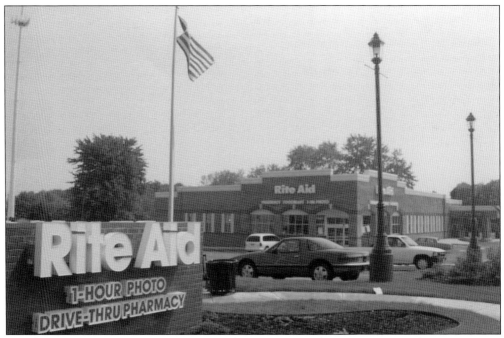

The Rite Aid drugstore took over the northeast corner of Broadview and Wallings Roads, where Gunner's IGA market once stood. (Courtesy of CBH.)

The new Wellpointe Shopping Plaza featured Pazzos Restaurant on the northeast corner of Broadview and Royalton Roads and the University Hospital Parma Wellness Center in the center of the plaza, which was named after the wellness center, its prime tenant. (Courtesy of CBH.)

George Woelfl served as mayor from January 1, 1968, to January 1, 1970. Woelfl was a longtime resident who was active in his church and the community. He campaigned on improvements needed for Broadview Heights and took advantage of a campaign statement from Mayor Fetzek's staff: "Why do you want to vote for a man who carries his lunch to work in a lunch bucket?" Since most of the residents did carry their lunch to work in a lunch bucket, the majority vote went to Woelfl, and he became the sixth mayor of Broadview Heights. (Courtesy of CBH.)

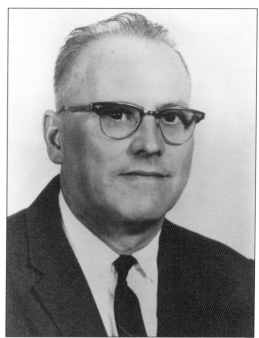

Mayor Woelfl installed new road signs to help drivers find Harris Road after completion of the Royalton Road addition that moved and realigned this turn, giving drivers a straight four-lane roadway from Interstate 77 east to Brecksville Road. Harris Road still ends at old Route 82. (Courtesy of the Woelfl family.)

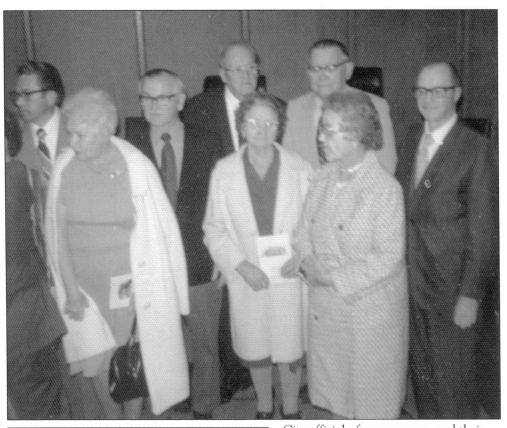

City officials, former mayors, and their wives gathered for a meeting. From left to right are (first row) Rose Mary Bender, Sophie Woelfl, and Anna Vitt; (second row) Mayor Frank Novy, Mayor Leo T. Bender, Mayor George Woelfl, service director Frank Vitt, and Mayor Gilbert Manke. (Courtesy of FF.)

Frank J. Novy served as mayor from January 1, 1970 to June, 1971. Novy became the second mayor to resign from office due to health reasons. Upon his resignation, Leo T. Bender, council president, became mayor for the second time, as designated by the charter of Broadview Heights. (Courtesy of CBH.)

Donald A. Faulhaber served as mayor from January 1972 to December 1977. During his administration, the council voted to change the start date of the term of office for mayor and the council to the Monday after the November election. Mayor Faulhaber did not run for office after his third term in 1977. In the following mayoral election, no candidate received a majority vote, so a runoff election between Edna Deffler and William Bittle was held in December. The winner was Edna Deffler, who assumed office according to the new schedule. (Courtesy of CBH.)

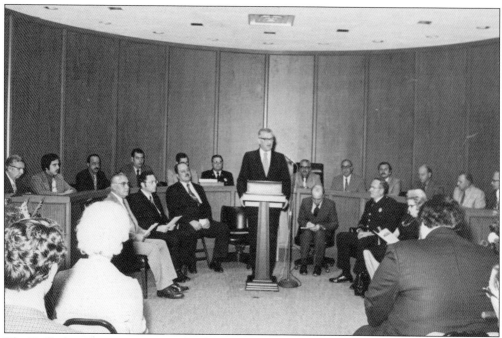

The Faulhaber team prepares to take the oath of office for their second term (1974–1976), with Andrew Cornish as master of ceremonies. (Courtesy of CBH.)

Ohio Machinery is the largest employer in the city of Broadview Heights. The company is expanding with a huge addition to be completed in 2016. (Courtesy of CBH.)

Edna Deffler served as mayor from December 1977 to May 1981. Deffler was appointed on May 13, 1981, to fill the unexpired term of state representative Donna Pope, who had accepted a position as director of the US Mint under Pres. Ronald Reagan. (Courtesy of CBH.)

Harry Jurkiewicz served as mayor from May 13, 1981, to November 1981. Jurkiewicz was council president when Edna Deffler resigned, so he became mayor for the balance of her term. (Courtesy of CBH.)

William Bittle served as mayor from November, 1981 to November, 1985. During Bittle's time in office, the mayoral term was extended to four years. (Courtesy of CBH.)

The Huntington Bank building is shown here in the 1990s. Other new buildings in the Crossing and Broadview Crossings shopping centers can be seen on the northwest corner of Route 82 and Broadview Road. (Courtesy of CBH.)

Leo H. Bender served as mayor from November 1985 to December 2003. Leo H. Bender is the second-longest-serving mayor, and he and his dad, Leo T. Bender, are the only father-son mayors in the history of Broadview Heights. (Courtesy of CBH.)

First Lady Judy Bender and Mayor Leo H. Bender were greeted and congratulated on winning the election by former mayor Donald A. Faulhaber and former first lady Lenore Faulhaber. (Courtesy of CBH.)

Mayor Leo H. Bender is ready for a day's work. With the mayor's office becoming a full-time position, Bender was able to achieve a number of beneficial projects for Broadview Heights. (Courtesy of CBH.)

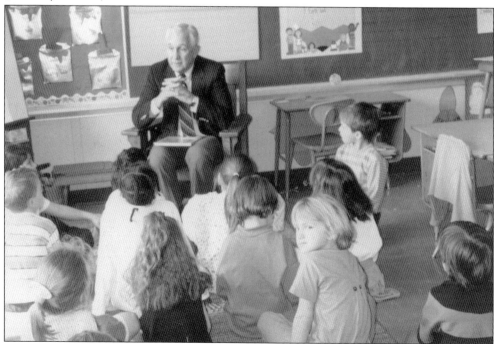

Mayor Leo H. Bender had a good relationship with both the Brecksville–Broadview Heights and the North Royalton school systems and conducted classes not only for future voters, but also for middle school and high school students. (Courtesy of CBH.)

Glenn R. Goodwin served as mayor from December 2003 to December 2007. Mayor Goodwin reinstated the words *Memorial Park* on the same sign as the fields. Memorial Park was established in 1952 as a place where all residents, especially veterans, could gather to play ball, picnic, or just socialize. Keeping the past alive is always a benefit for the future. (Courtesy of CBH.)

On, May 31, 2004, Mayor Glenn Goodwin and the city council dedicated the main street entering the Broadview Heights City Complex in memory of former mayor Donald A. Faulhaber. The many accomplishments and improvements that occurred during Faulhaber's term in office were for the betterment of Broadview Heights. His wife, Lenore, and Mayor Goodwin pose in front of the new sign for Faulhaber Memorial Drive. (Courtesy of FF.)

Samuel J. Alai took office as mayor in December 2007. His motto, "Believe in Broadview Heights," has achieved a level of success, and now into his third four-year term, Alai will continue to keep the community the "Highest of the Heights." (Courtesy of CBH.)

Six

HOMES

The first homes in the area that is now Broadview Heights were built along Broadview Road in the early 1800s when Brecksville and Royalton Townships were founded. As more settlers arrived, the southern part of town saw the biggest increase of homes and family farms. Only a few of the original homes survive today. The first farmhouses were constructed in the log cabin style. Trees were cut into logs, then laid on top of each other, and the space between them was clinked with clay. Most cabins were 18 feet square. The floor was made of packed mud, flat rock, or ledge stones, and windows were made of greased paper or cloth. When logs could be cut into boards, the farmers built basic homes consisting of a kitchen, bedroom, and living room. As the family grew, additions were made to accommodate more people. The style did not change much until the 1950s and 1960s, when the majority of new homes were simple three-bedroom ranch homes on half-acre lots. As land became more expensive and property taxes increased, farmers began selling to developers who built groups of houses on the farmland rather than on main roadways. Today, the houses are constructed in a variety of sizes, styles, and shapes. The growth of Broadview Heights, with a total population approaching 20,000 in 2015, shows how planned zoning, residential growth, and proper elected officials worked to make Broadview Heights an ideal community to live, work, and play.

Capt. Jared Clark built this brick house at 6241 Wallings Road in 1853. The date is etched into the keystone over the front door. The inscription "Temple of Freedom" is also carved into a huge stone above the door. Rumor has it that the home was a stopover for the Underground Railroad during the Civil War, providing relief for slaves escaping the South and heading to Canada. Despite extensive research and excavations around the home in search of tunnels or other avenues of escape, no one has been able to prove this theory. Clark was a heavy drinker, much to the shame of his family. Before the house was built, Clark and his family attended a temperance meeting, after which he walked up to the table and signed the pledge. Not a word was mentioned by either him or his family, but he never drank a drop of liquor after that. Records indicate that the inscription was engraved above the door to signify his freedom from any type of alcoholic spirits. (Courtesy of BHHS.)

Rose and Jake Trapp's house was built in the late 1920s in the western style, with the living room, dining room, kitchen, and small bathroom on the first floor and three bedrooms upstairs. The trellis on front of the house was Rose's idea because she enjoyed having clematis flower vines growing up it during the summer months. (Courtesy of the Trapp family.)

The Trapp barn, which was smaller than most, was used more as a storage garage rather than a traditional barn to keep hay and wheat. The lower level provided a place for the cow and chickens to fit nicely into the back of the property. (Courtesy of the Trapp family.)

Virginia Behal married Johnny Kleinpell on July 16, 1917. Virginia's father, Vaclav, ordered a precut house kit from Sears, Roebuck & Company and built the house on Avery Road near the farm of Johnny's parents. This photograph shows the house today, still in excellent condition as it approaches 100 years in 2017. (Courtesy Behal family.)

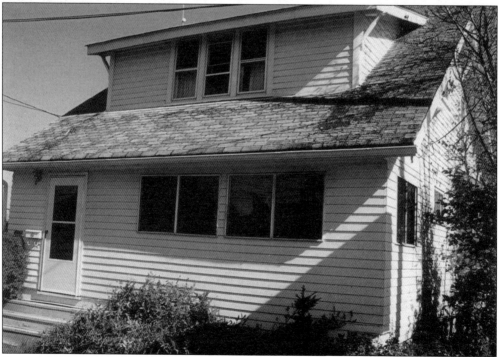

George Clogg had an insurance agency and real estate business located in his home. Built in the western style, the house is still standing on the east side of Broadview Road, just north of Wallings Road. (Courtesy of BHHS.)

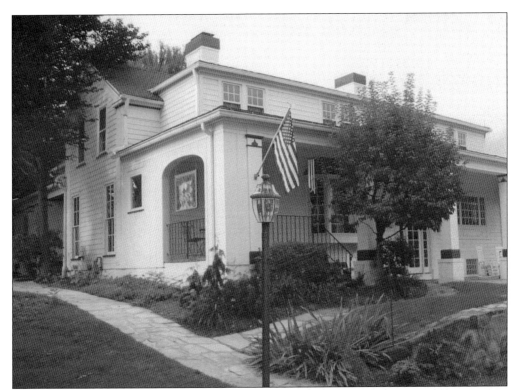

The Avery home was built in 1869. In addition to a large barn and outbuildings, acres of land provided pasture for raising beef cattle, chickens, and produce. In the 1950s, the Bileks were the last family to work the farm in this large format. (Courtesy of BHHS.)

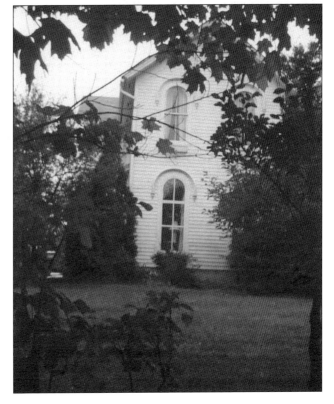

This early American home on Wallings Road was always referred to as the Cornish house after owners Andy and Tory Cornish, not because of the cornices above the windows. Andy would refer to his gravel driveway as early American—no concrete or asphalt for him. (Courtesy of BHHS.)

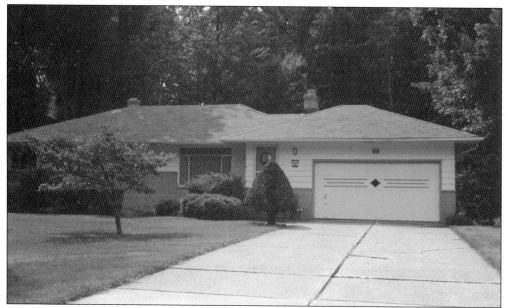

The Wallings Meadows development was built in the late 1950s and early 1960s, taking land from the Wright and Wyatt family farms. The extension of Wright Road and new roads like Marianna Boulevard, Joyce Road, Lenwood Drive, Craig Lane, Diana Drive, Louis Road, and Ashley Drive allowed over 70 new families to move into Broadview Heights at reasonable prices for basic three-bedroom ranch houses. (Courtesy of BHHS.)

This view of Creekside Drive off Wallings Road, just west of the Wallings Meadow development, shows the new style of homes now being built in Broadview Heights, ranging in price from $300,000 to over a million dollars. (Courtesy of BHHS.)

The Broadview Heights city sign was adapted by Mayor Sam Alai when he took office in 2007. The design shows the awards the city has been presented by various agencies, rating Broadview Heights as the safest city in Ohio, as well as the best place to raise a family within the state. (Courtesy of BHHS.)

DISCOVER THOUSANDS OF LOCAL HISTORY BOOKS FEATURING MILLIONS OF VINTAGE IMAGES

Arcadia Publishing, the leading local history publisher in the United States, is committed to making history accessible and meaningful through publishing books that celebrate and preserve the heritage of America's people and places.

Find more books like this at
www.arcadiapublishing.com

Search for your hometown history, your old stomping grounds, and even your favorite sports team.